ARTS DÉCORATIFS 1925

ARTS DÉCORATIFS 1925

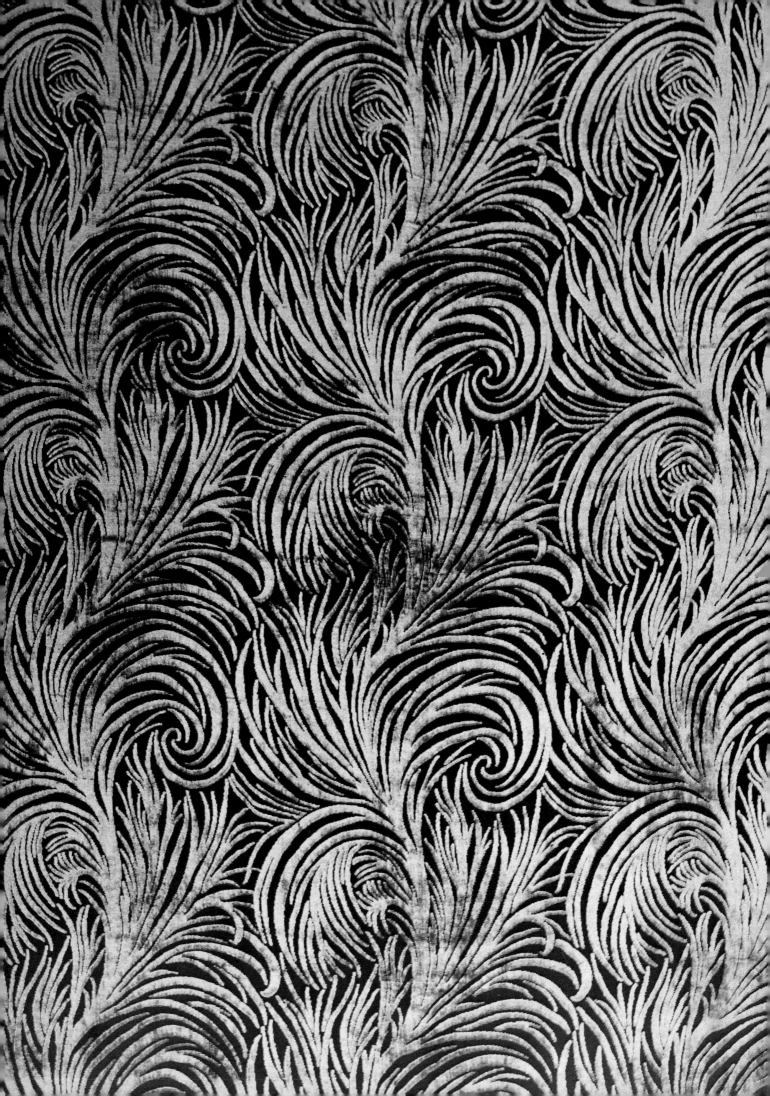

ARTS DÉCORATIFS 1925

A PERSONAL
RECOLLECTION OF THE
PARIS EXHIBITION

FRANK SCARLETT

MARJORIE TOWNLEY

ACADEMY EDITIONS · LONDON/ST. MARTIN'S PRESS · NEW YORK

(frontispiece) Broche velvet design by Marjorie Townley, executed by Courtaulds Ltd.

ACKNOWLEDGEMENTS

Firstly, we must acknowledge the help given by the Bibliothèque de la Musée des Arts Décoratifs, Palais du Louvre, Paris, and by M. Alain Weill particularly, where it was possible to work undisturbed overlooking the gardens on cool sunny days. In London, the Library of the Victoria and Albert Museum and that of L'Institut Français du Royaume Uni gave us much assistance for which we are grateful, as well to the Brighton Museum, The Royal Institute of British Architects and the Architectural Association, where the unsurpassed photographs of F.R. Yerbury were obtained. We thank the Goldsmiths Company for allowing us to have the illustration of the chafing dish by Henry Wilson and the Museum of Decorative Art, Copenhagen, for the photographs of the 'Wounded Bull' by Paul Gauguin.

On a personal level, Olga and Marcelli Karczewski gave us a lot of help about the Polish Section and H.T. Cadbury-Brown, by the timely loan of a book, helped verify the memories of Wembley. The works of Martin Battersby on *Art Nouveau* and *The Decorative Twenties* and that on *Poiret* by Palmer White should be mentioned as the most interesting among a number of others including *Les Arts Décoratifs Modernes* (France) by Gaston Quenioux, Librarie Larousse, 1925. In dealing with the antecedents, Mark Girouard's articles in *Country Life* were of great assistance and Nikolaus Pevsner's *London,* volumes I and II, from *The Buildings of England* indispensable. Lastly, but by no means least, we must thank Miss Jane Ashelford for an excellent job on picture research and Miss Stephanie Diprose for deciphering, typing and retyping successive drafts of manuscript.

The following are acknowledged for their kind permission to reproduce photographs: the Victoria and Albert Museum, London (pp. 15, 16, 17, 52, 55, 69, 87, 96-97); The Architectural Association, London (pp. 27, 58, 66, 89, 91, 92, 93); la Musée des Arts Décoratifs, Paris (pp. 36, 61, 88, 90); Mr. Martin Battersby (pp. 33, 34, 53); Editions Graphiques, London (pp. 69, 70); the Museum of Decorative Arts, Copenhagen (p. 91); The Goldsmiths Company, London (p. 71); Mr. Michael Jones (p. 51); and *Architectural Record* (p. 99).

First published in Great Britain in 1975 by
Academy Editions 7 Holland Street London W8

SBN 85670 257 9

First published in the U.S.A. by St. Martin's Press Inc.
175 Fifth Avenue New York N.Y. 10010

Printed and bound in Great Britain by
Balding & Mansell

CONTENTS

FOREWORD

In writing this book to celebrate the fiftieth anniversary of L'Exposition des Arts Décoratifs et Industriels Modernes, Paris 1925, it was not the intention of the authors to undertake a work of research. It is instead an attempt to record the recollections of two enthusiastic young people who happened to have held temporary appointments on the staff of the British section of the Exhibition and there developed a life-long friendship.

In the light of maturity, it may be possible to suggest the stylistic sources of the confluence of movements which formed and is now recognisable as Art Deco and to suggest its influence upon the work that followed. We shall try to emphasise the good rather than the bad even if the latter predominated and, therefore, cannot be ignored.

If, in the course of looking back over the past in the light of the fifty years' experience and knowledge gained since, we appear critical of those for whom we were working, it is regretted, because they were all charming people and very kind to both of us. On the other hand if we appear to over praise, it must be excused as nostalgia for the days of our youth.

Much reference has been made to the official British Government Report on the exhibition published by the Department of Overseas Trade. After the exhibition opened, Frank Scarlett was asked to stay on and make a survey of the whole of the exhibition for the guidance of the experts who were to come from Britain to compile the various chapters of the book. Unfortunately, all his notes made at the time were lost during the second World War, so that the Report forms one of the main sources of reference. The full title is: *Reports on the Present Position and Tendencies of the Industrial Arts as indicated at the International Exhibition of Modern Decorative and Industrial Arts, Paris 1925 with an Introductory Survey. Department of Overseas Trade.*

F.S.
M.T.

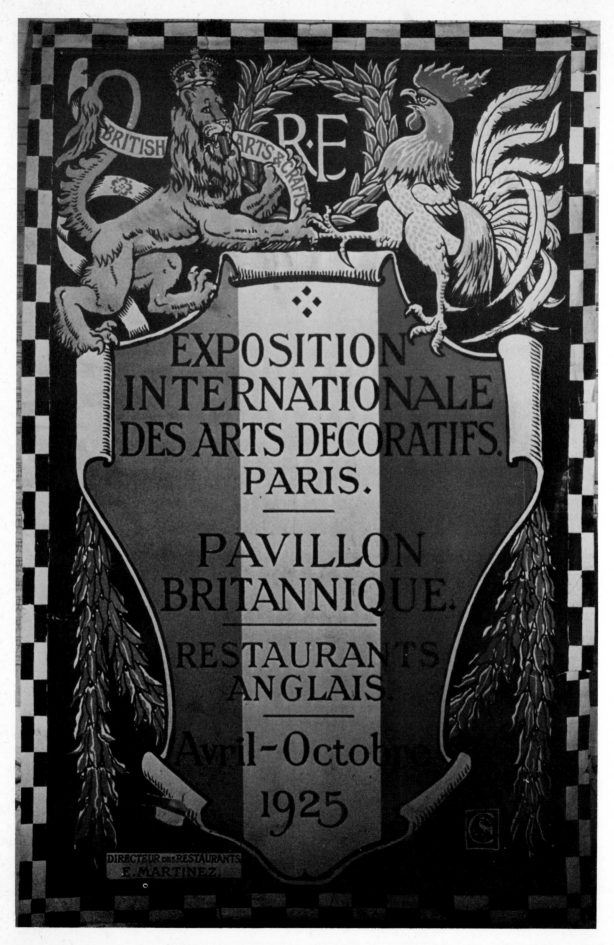

Menu cover by Walter Crane for the British Pavilion

GENESIS

The Paris Exhibition of 1925 was the first French International Exhibition since 1900. Originally proposed in 1913, but abandoned owing to the War, the idea of a French exhibition was revived by the French Government in order to assert the tradition, epitomised by Colbert's decrees, of French world leadership in the arts.

The organising authorities decided that the exhibition should cover a wide field of contemporary industrial and decorative art, the limiting conditions being that reproductions or mere copies were excluded and that all exhibits should display genuine originality, fulfil a practical need and express a modern inspiration.

The exhibits were classified under five main groups and 37 categories, ranging from:

Group 1 Architecture, Class 1 (i) Architecture carried out....
to
Group V Instruction, Class 37, Photography, Cinematography....

This selection embraced a very comprehensive list of all forms of art in all known materials, excluding only pictures or statues not conforming strictly to a decorative whole, technical or mechanical processes and sketches or rough models.

The site and layout of the Exhibition was boldly conceived and embraced the whole of the Grand Palais, the Cours La Reine, the Pont Alexandre III and the Esplanade des Invalides. The main entrance adjoined the Grand Palais in the Place Alexandre III, and some fourteen other gateways were disposed around the perimeter of the enclosure, of which the most impressive was that from the Place de la Concorde.

The Meaning of Art Deco

At the close of the Great War, or the first World War as it so tragically came to be known, France, who in the last quarter of the 19th century and the first decade of the 20th had so brilliantly led the world as a centre of what was known as the *beaux arts*, was cruelly weakened. Two million men of the younger generation out of a total population of around 38 million lay dead on the battle fields; amongst them was certainly a large proportion of those who otherwise would have been the nation's intellectual leaders. There had also been a gap of nearly five years in the continuity of aesthetic thinking, and it was virtually impossible to pick up the threads which had been broken.

However, as had happened more than once in the nation's history, a national disaster had been followed by a resurgence of cultural activity, and this time the accent was to be on the so-called decorative arts. Art Nouveau had been stopped in its tracks, though the lessons learnt from this experimentation were to prove valuable to the new generation of designers, a few of whom had learnt their craft before the war.

Encouragement for this revival came in great measure from the Ministry of Fine Arts, and the fact that the state controlled important factories, such as the Gobelins, Sèvres, etc., contributed not a little to the financial backing needed for such an artistic resurgence. Psychologically, it was important that France should maintain her cultural vitality in these fields; commercially, it was equally important to encourage the many trades involved in order to develop their potential. In addition, many people felt that there was little justification for assuming that the 'fine arts' were superior to the decorative arts and that it was absurd to use the centuries old skills of the cabinet makers, potters, weavers, metal workers, etc., solely for the purpose of accurate reproduction of historical styles.

With the honourable exception of the homes of those who has actually invested in Art Nouveau furnishings, the average dining room at this time was 'style Henri IV', Monsieur's study was 'Premier Empire' with finely executed bronze and gilt accessories and Madame's drawing room and bedroom were a veritable nursery of delightful rococo cupids from the plasterwork on the elaborate cornices ('patisseries' as they were scornfully dubbed) and the marble and gilt clock with attendant vases on the mantelpiece to the draperies that adorned the bed, with the elaborate

gilt 'couronne' from which they depended.

However, there was nothing in all this that could remotely satisfy the urge to create a worthy contemporary art, an art expressive of the age. At this period in time, man-made materials had barely made their appearance. Courtaulds, it is true, had made a notable beginning with their development of artificial silk, while tubular and stainless steel had been effectively employed, but for the most part, the materials and skills were traditional, though the cabinet maker had the advantage of using rare woods and veneers imported from abroad. Money, of course, had changed hands, and the 'nouveau riche', in his laudable desire to demonstrate his judgement and good taste, contributed not a little to the willingness of makers and retailers to satisfy his demands. The bathroom was the one room in the house in which the designer could experiment boldly and indulge the fancy of his patron. There had been no proper bathrooms since the fall of Rome, and even the Victorian tin bath had been copied from museum specimens. There were, therefore, no restrictive precedents. These luxurious rooms deserve a chapter to themselves, sunk baths, built-in baths, marble, mosaic, murals, but it is impossible to gauge how many of these have survived.

Before the irresistible logic of functionalism and the still more irresistible logic of the depression enforced restraint, there was a happy period, between about 1920 and 1928, which reached its zenith at the great Exposition des Arts Décoratifs in Paris in 1925. 'Art Deco' was a distinct style reflecting the sheer joy in the beauty of materials, while the designer's skills were undeniable. In England, the designers and craftsmen existed, but, unfortunately, the demand and the willingness of manufacturers to co-operate were negligible so we cut but a poor figure at the Exhibition.

The subject of our study has now passed into history, and after fifty years we are better placed to see it in its proper context and to make a reasonable assessment of its aesthetic value. Although, apart from Art Nouveau, there had been little attempt to create a contemporary style for nearly three quarters of a century, this modern work was in legitimate descent from the classical periods. The principles of construction and manufacture had not changed; comfort and elegance were still the aim. Nevertheless, although it was perfectly possible to mix furniture of different epochs in a well balanced interior, after such a long static period, it was nothing less than 'shocking', to use the 'franglais' of the time, to introduce a modern chair or table. Indeed, a few years later I (M.T.) remember, in Waring's 'George the Fifth Period Department', an indignant lady exclaiming excitedly, 'Surely, they never made furniture like this in the time of George the Fifth!' The salesman replied with commendable restraint and dignity,

'George the Fifth is our present King, Madam!'

It was a great battle, but the forces of change were on the side of the more adventurous spirits. Léon Bakst and, subsequently, Paul Poiret opened a new and glorious epoch in stage presentation; their glowing colours were a veritable revelation. Greatly improved methods of colour reproduction resulted in a spate of finely illustrated and produced books, particularly in England. Of course, women's clothes, always regarded in France as an important branch of decorative art, had changed as the way of life had changed. Hair was shingled, bobbed or Eton cropped under 'cloche' hats. Skirts were shorter, smoking was fashionable with the usual long and sometimes jewelled cigarette holder.

The economic forces that were to favour functionalism in design were yet to come into play. It was obviously going to be much cheaper to base design on well proportioned cubes and rectangles than to indulge in bow fronts, carved mouldings and inlays of rare woods and ivory. Hand work still had an immense prestige, while hand blocked linens, batiks, wood block illustrations, leather work and book bindings often displayed considerable talents.

The art of the 'ensemblier', who made good use of all these different skills, was understood and formed the basis for the studios opened by the leading Parisian stores: Primavera, Pomone, La Maîtrise, etc. The names that spring most to mind, Ruhlmann, Paul Follot, Maurice Dufrêne, Süe et Mare, Léon Jallot and others produced work of exceptional quality. The 'verriers', Lalique and Daum, the metallurgists, Edgar Brandt in particular, and a host of other specialists in all the many crafts together contributed to a remarkable revival of the decorative arts and gave to their period its distinct character.

The style of this period must not be confused with what came to be known as 'modernistic', the replacement of the sinuous curves of Art Nouveau by the right angles much favoured by cinemas and trendy hotels. Nor indeed ought it to be linked to the aesthetic philosophy underlying the movement known as De Stijl, which soon replaced Art Deco and coincided with the rapid development of new methods of construction, man-made materials and the processes of mass production. This is a different and continuing story, but in the meantime, it is worthwhile to consider the intrinsic merits of Art Deco, as displayed at the Exhibition in 1925, perhaps the last manifestation of individual designs individually produced.

The Layout of the Exhibition

The site gave the Exhibition incomparable advantages. The Grand Palais, its interior transformed and amplified, the trees and existing classical buildings of the Cours La Reine formed a suitable backcloth to the

national pavilions. The bridge and the river with its quais by night and day gave a focus and spread the brightness of La Ville Lumière, while the dominating Dôme des Invalides was a reminder of the traditions and history of France. The exhibition stood within the heart of Paris when Paris was the heart of the world.

From the Porte d'Honneur, the national pavilions spread along the river frontages to the left and to the right. The British Pavilion shared with the Italian the most honourable position on the right of the main entrance; then followed the Turkish, Danish, Swiss and Greek Pavilions, all showing great diversity and character, the international style having yet to consolidate. On this side was also the Russian Pavilion. Although disparaged at the time, it was, perhaps, the most original creation of all and only recently has received belated approbation. Tucked away in a far corner was the Pavillon de l'Espirt Nouveau, the first executed work by Le Corbusier that the writer (F.S.) had seen. In this area was also built a number of French colonial pavilions.

Still on the north bank but to the east of the

bridge were ranged the Japanese, Austrian, Monégasque, Swedish, Polish, Belgian and Dutch Pavilions, of which the Dutch, Polish and Austrian provided the three most outstanding architectural contributions.

The river frontage was developed with restaurants and cafés on the upper level and barges moored to the lower quays. There were the Viennese café and the Restaurant Britannique with its péniche, a Seine barge converted to a night club.

The Grand Palais formed the official centre for ceremonies and receptions and contained a number of displays of various industrial arts both French and foreign.

The French sections were spread in many pavilions on the South Bank occupying most of the Esplanade des Invalides, centred on the Ambassade Française, and pavilions representative of the regions and cities of France such as the Franche-Comté, Nancy, Mulhouse, Roubaix and Tourcoing and Provence.

Illuminations of the Pont Alexandre III, cascades below and boutiques above

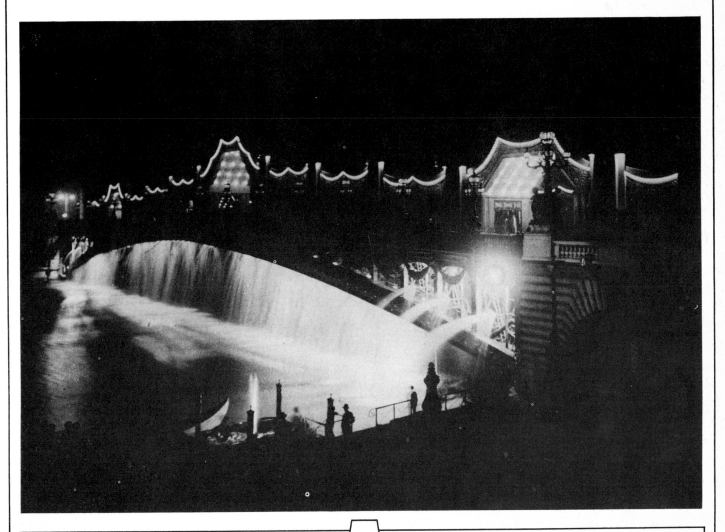

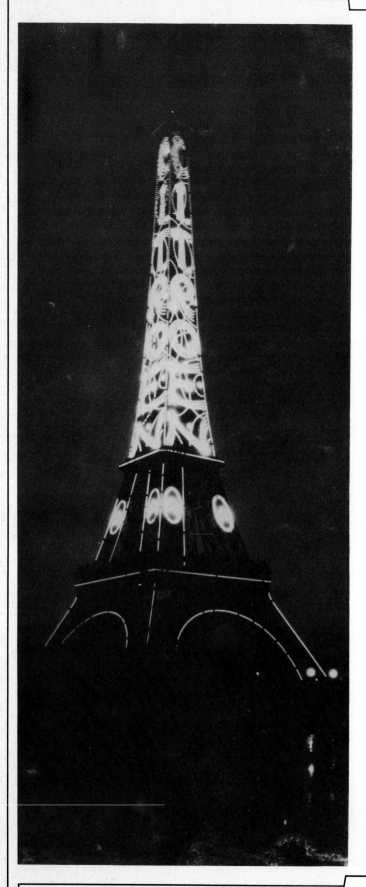

Then there were the State Manufactories, for example, Sèvres, and the department stores including the Louvre, Galeries Lafayette, Printemps and Bon Marché, who had their representative buildings. Four towers of the wine growing and gastronomic Departments of France emphasised their importance in the life of the country. One's recollection is of novelty and delight, whether entering from the Place de la Concorde, or the Avenue Alexandre III, to the dapplied avenues of the Cours La Reine, opening out to the Esplanade des Invalides, whether in the sunlit afternoon or the incandescent glow of the evening reflected in the Seine.

It is extraordinary to recollect that the transformation was effected with comparatively little disturbance to the traffic flow in the city and it is believed that no trees were sacrificed and practically no dislocation was caused to the essential services of the city.

The Eiffel Tower illuminated

THE ANTECEDENTS OF ART DECO IN BRITAIN

Arts and Crafts

Although Ruskin, in his later years, deplored the unfortunate results from misunderstanding his books, it was the *Seven Lamps of Architecture* and *Modern Painters* which were the inspiration of William Morris and his followers in the progressive movement in the arts during the second half of the nineteenth century. It is reported that William Morris looked around at the Great Exhibition of 1851 with a doleful countenance and remarked 'it is all so wonderfully ugly', and, thereafter, pursued a vision of beauty in the surroundings not of a privileged élite but to be achieved and enjoyed by all as the reward of honest toil.

While his greatest achievement may have been in wallpaper design and typography, Morris was also a writer and poet of merit; in addition, he and his associates produced textiles, furniture and stained glass. Their versatile activity in all branches of interior design materialised in the Red House, built in 1859-1865 to Morris's direction by the architect Philip Webb. This demonstrated a wholeness and simplicity of approach that spread its influence over Europe and the United States. The high-mindedness of the character of William Morris was expressed in strong, pure colours in paint or dye, red brick and solid work in native woods, while his capacity for sensitivity and refinement can be seen in the rooms which he decorated in St. James's Palace.

On leaving Oxford, Morris had worked as an articled pupil in the office of George Edmund Street, and it is not surprising that the Red House, with its square plain and pointed windows, gabled and hipped steep pitched roofs, has some affinity with Street's country vicarages. The differences come in the richness of its interiors, the great settles and sideboards made specially for the house by Webb or Morris, the painted panels and stained glass in which Burne-Jones, Rossetti, Morris and Webb all had their part.

The most attractive aspect of the exterior of the house is from the interior angle at the back with a view of a square stair tower and large well head with a conical tile roof. Curiously, it is the windows of the passages and domestic offices that look out in this direction. The Red House was lived in from

1889 by Charles Holme, a successful textile manufacturer, who, after retirement, was instrumental in starting and then financed *The Studio*, a periodical which did much to publicise the work of original designers and in which much of the work of Aubrey Beardsley, whose drawings inspired and expressed the spirit of Art Nouveau, was first presented. The firm of Morris and Co. lasted until 1940, when it went into liquidation, and some of its products appeared in Paris in 1925.

While the ideal of an established group of artists and craftsmen working together did not survive, the pioneer work of Morris bore fruit in those who followed in the late nineteenth and early twentieth centuries. The work of Philip Webb attained maturity at Glebe Place, Chelsea, and in Standon, as did Norman Shaw's in his three houses, the most romantic of which is Old Swan House, on Chelsea Embankment. Their common characteristics were a freedom from the restraints of style and the realisation that the design of a house does not finish with the plans and elevations but extends into every detail of the interior. Both were greatly interested in the survival and stimulation of the traditional building crafts, many of which already were becoming obsolete.

'Aesthetic'

In 1870, Edward Godwin, architect, stage designer and father of Gordon Craig, built the White House in Tite Street, Chelsea, for Whistler. The house can only be appreciated from drawings, since before it was demolished quite recently, it had been altered so much that its original character had disappeared. To quote Pevsner, the street façade had 'white brick and Italian motifs displayed so asymmetrically and wilfully that the total effect is almost Art Nouveau', and, I would add, completely charming.

The White House was followed by a number of projects for the same street of which, unluckily, only a few have survived. A block of double storied studios known as the Tower House still looms above the adjacent house which Godwin built for Frank Miles. The original design was even more exciting

than that which actually was built. A strong contrast of opposing vertical and horizontal emphases was controlled by both the golden section and the balconies, designed for the incorporation of plants and decorative panels contrasting with plain wall surface. Though both Miles and his architect were inspired by Japanese art, it was nevertheless an outstandingly original design and, no doubt for this reason, was rejected by the ground landlords, who were the Board of Works. Godwin's furniture also shows the influence of Japan but was transformed by his own personality. There is also a theatrical element in his architecture, although it is more substantive in the sense that the work of some of the nostalgic mediaevalist imitations of William Morris is not.

In contrast, simplicity of design was epitomised by C.F.A. Voysey, who is well represented by Annesley Lodge, Platts Lane, Hampstead, with its rough cast walls, deeply pitched slate roof, strongly featured buttresses and chimneys. The 'L' shaped plan is well placed on the corner site. Inside and out, the house has the greatest simplicity. Voysey's inspiration was derived from English Mediaeval architecture and craftsmanship, and he was unsympathetic to eclecticism and progressive expression in the arts. His designs for textiles, wallpaper and interior woodwork show the imprint of a strongly original mind, and he was, I believe, a friend of Sir Hubert Llewellyn-Smith, who was greatly concerned with the subject and,

indeed, with the material of this book, probably sharing a similar outlook in aesthetic matters.

Art Nouveau

There are two houses (nos. 33 and 39 Cheyne Walk), in Chelsea by C.R. Ashbee of which the narrow windows, steeply pitched gables, stilted proportions and above all, the iron railings, point to Art Nouveau, although the small white window panes and the trim red brickwork foreshadow the Georgian revival. The same ambivalence is apparent in some of Philip Webb's houses, although he is also believed to have professed himself a true Gothicist to the end of his life. The railings and the light fittings were probably made in Ashbee's own Guild of Handicraft at Essex House.

There is a little surviving work, at any rate in London, by that original architect and designer M.H. Baillie-Scott. I remember a lovely house in Avenue Road, where a block of flats now stands, that was demolished in the late 'twenties. Another work of his, Waterlow Court in the Hampstead Garden Suburb, consisting of flats and common rooms for

Original design for Frank Miles's house in Tite Street, Chelsea

The Red House, Bexley Heath, drawn by John Burkett

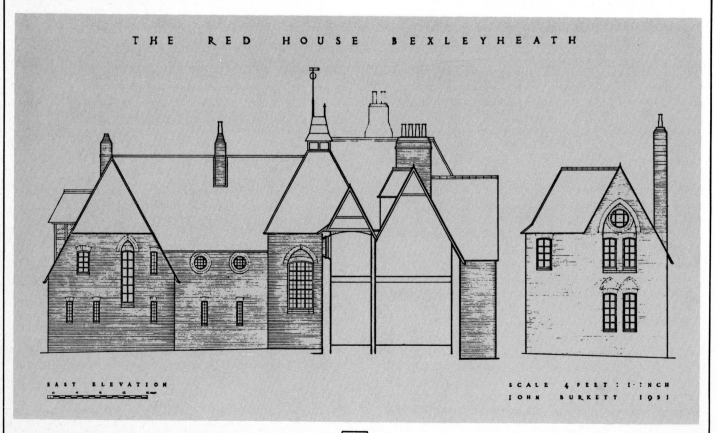

THE RED HOUSE BEXLEYHEATH

EAST ELEVATION

SCALE 4 FEET : 1 INCH
JOHN BURKETT 1951

FOR F. MILES ESQ.

'TREET, CHELSEA.

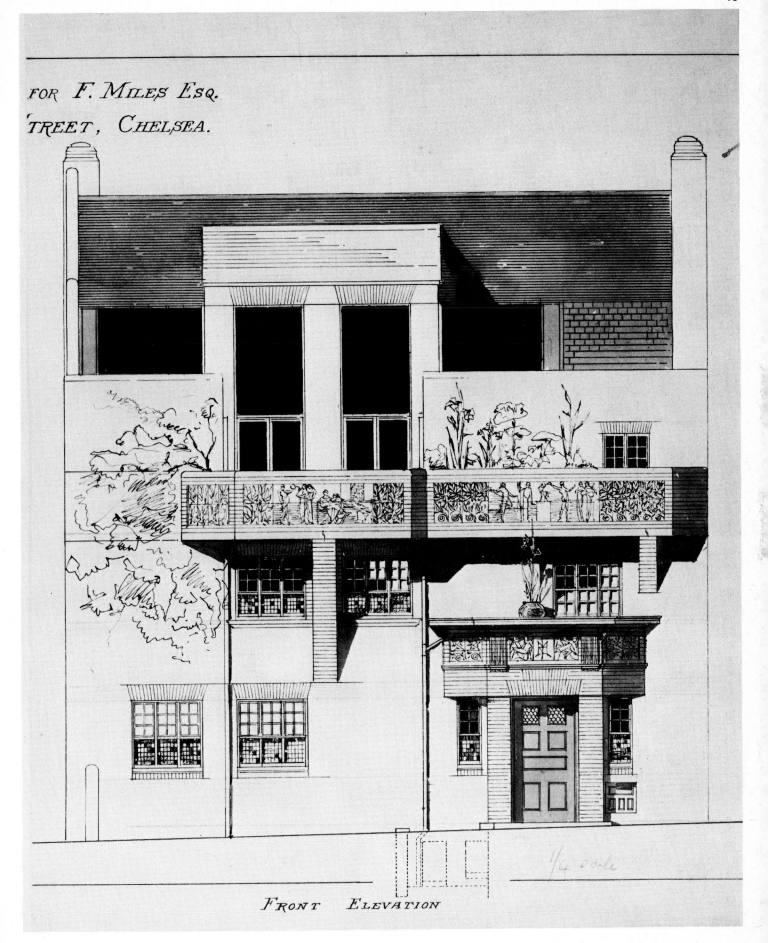

FRONT ELEVATION

¼ scale

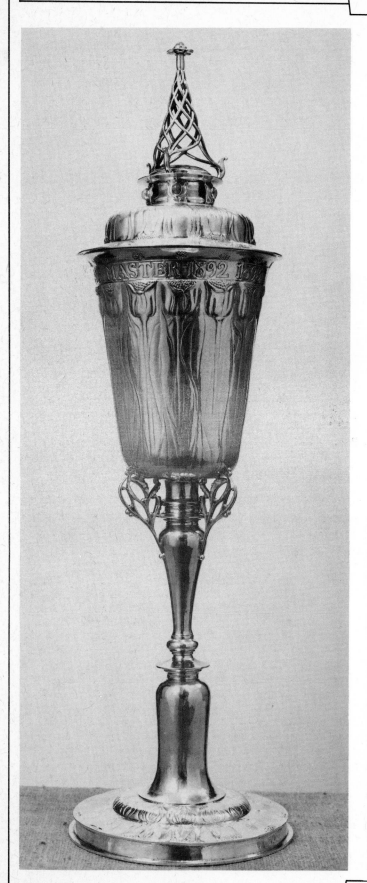

professional women, fortunately still survives in pristine cloistered charm, as does a group of three beautiful houses at the corner of Meadway and Hampstead Way.

Baillie-Scott's furniture is remarkable for its elegance of proportion and sensitive use of colour. Among his works were interior designs for the new Palace at Darmstadt for the Grand Duke of Hesse. Although from his drawings, the designs for individual pieces, painted in white, orange and green, have a charming simplicity, photographs of some of the rooms show them to have been, to modern taste, over furnished. There is a delightful series of drawings of a design for a 'country house' published in *The Studio* for 1900, which has a two storey hall with an 'upper gallery', 'refectory', 'ladies' bower' and 'den' opening directly from the ground floor. The exterior is of the utmost simplicity, and the open plan of the interior is realised in Baillie-Scott's charming water colours. In the eighteen-nineties, he and Charles Rennie Mackintosh were among those who helped to establish Art Nouveau as a fully developed style and whose influence spread abroad, particularly to Vienna.

Holy Trinity, Sloane Street, J.D. Sedding's masterpiece also must be mentioned. This building is a splendid and successful amalgam of Gothic and early Italian Renaissance motifs and contains the work of a number of artist craftsmen. The stained glass windows are by Burne-Jones and William Morris and Co.,

Mazer from C.R. Ashbee's Guild of Handicraft

House in Cheyne Row, Chelsea, by C.R. Ashbee

and, particularly interesting in the context of this book, the altar rail, the grille behind the altar and the external railings to Sloane Street are the work of Sedding's pupil, Henry Wilson, who will be discussed below.

Interest in social purpose is expressed in the Mary Ward Settlement in St. Pancras by Dunbar Smith and Cecil Brewer, which has an interior simplicity of form and purity of colour. The fireplaces were designed by Ernest Newton, Guy Dawber and W.R. Lethaby. The first two architects later became more traditional in outlook, but Lethaby remained, in his writings and in his building, in the mainstream of a living tradition, as exemplified by Melsetter House in the Orkneys and his articles in favour of developing machine production in furniture.

The culmination of Art Nouveau in England can be seen in the Whitechapel Art Gallery by C. Harrison Townsend. Built of stone with slightly battered walls and rounded corners and a ceramic frieze by Walter Crane, it has sculptural quality. The Horniman Museum in Lewisham is by the same hand. The fully developed Art Nouveau manner, however, did not evolve much further in Britain and was soon superceded by quiet, if not ghastly, good taste. Its influence spread quickly, however, to central Europe, where it was called the 'Jugendstil'.

To summarise the developments of the second half of the nineteenth century, William Morris and his disciples were earnest, sincere and high minded, enjoyed bright colours, natural materials and believed that design would arise as a natural process from honesty of purpose in craftsmanship. They were contemptuous of paper architecture and designers' craft. Their weakness arose from nostalgic medi-aevalism, their failure to realise the potentiality of the machine and their lack of success in reaching more than a privileged minority. The creative spirit did not long survive the first decade of the twentieth century.

It will be seen that the ideas that it expressed remained in 1925, when the lingering worn out tradition was exemplified in much of the more prominent display work. To Henry Wilson, however, the spirit of a new era was a revelation and inspiration which he enthusiastically recorded in the official report.

20th Century Reaction

For several reasons the period of experiment was succeeded by a reaction towards neo-classical architecture and reproduction furniture. Firstly, there was renewed interest in the doctrines of the Ecole des Beaux-Arts, coming directly from the work in London by Sir John Burnet and by Mewes and Davis, and, indirectly, by way of America, where nearly all of the architectural establishment on the eastern sea-

board had been Beaux-Arts trained. Another of the reasons for this interest was that the individual leadership of the experimental period had left lesser architects without safe guide lines, and the climate was right for a new authority. Moreover, the establishment of schools of architecture, superseding the system of education by articled pupillage, made it necessary to establish theories and rules by which students could be trained, marked and examined. At the same time, another strong influence was the popularity of Kate Greenaway's and Randolph Caldecott's illustrations which turned eyes towards the charm of simple red brick houses and cotton frocks.

Chair by Baillie Scott

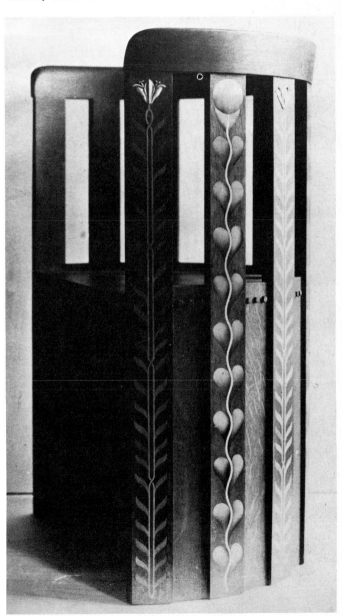

Wembley

More will be said about the architecture and crafts of Britain of the years 1900-1925 in dealing with the British Sections at the Paris Exhibition. A few words about the British Empire Exhibition in 1924 at Wembley, however, would be appropriate as it had direct bearing on the British display in Paris. The Wembley Exhibition was conceived on a very ambitious scale. Covering a great area of land and including exhibits from very many member countries, it aimed at displaying these in all their aspects, commercial, industrial, agricultural and artistic. It also leased a number of sites for the display, sale and provision of home products. The organisation of the whole of the British display was in the capable hands of Sir Lawrence Weaver, who combined considerable business ability with a lively and intelligent appreciation of the arts. The influence it had on the Paris Exhibition one year later and its ultimate value in the development of the industrial arts can only be considered in the light of what one remembers. Looking back over contemporary photographs, the general feeling is that they give a fair impression of the arts of Britain at that time.

The main buildings were the result of architect (Maxwell Ayrton) and engineer (Sir Owen Williams) working together in close collaboration and represented an attempt to give architectural expression to concrete construction for the first time in Britain on this scale. It was commendable that the architects designed not only the building but also all the external items such as lamp posts, signs, bridges over the lake and fountains, ensuring an overall unity of detail.

Within the main buildings, in predetermined areas, other architects were commissioned to design for individual or groups of exhibitors. For example, in the Palace of Industry there was the Pottery Section which included displays by various firms. These assignments were, on the whole, entrusted to the more progressive architects of that time, among whom were Oliver Hill, who later designed the British Pavilion for the 1937 Exhibition in Paris; Clough William Ellis, the architect of Port Meirion; Imrie and Angel, who contributed a delightful pavilion for the Electrical Development Association in the manner of a villa on the Mediterranean; and, perhaps the most forward looking of all, Joseph Emberton (of Westwood and Emberton), who was the designer of some interesting kiosks in the grounds, particularly that for Abdulla cigarettes. His very original pavilion for State Express cigarettes was, perhaps, the most advanced, anticipating the Odeon style of the 'thirties. There was practically nothing else that one can remember either in buildings or

exhibits that anticipated Art Deco as it was known in France and revealed itself a year later, except for the works of Oliver Bernard, stage designer, decorator and, most of all for want of a badly needed better word, artist-electrician. In collaboration with Maxwell Ayrton, he originated the brilliant scheme for the many restaurants in the grounds, which were mostly top-lit with plain exterior walls decorated with frescoes of his own design, applied by groups of art students, quickly, economically and very effectively. Though the Exhibition, apart from exceptions such as those mentioned above, could not have been said to have advanced the frontiers of art or craft, it did, I (F.S.) believe, extend the horizons of those who saw and participated in it. The very largeness and variety, its wide scope, together with individual views of great beauty, such as the flood-lit dome of the Indian pavilion reflected in the lake, did open the eyes of those who saw it and prepared them to accept a new spirit, even if much of the design was, if not banal, at least rooted in a tired tradition that was a long way from William Morris.

The Neo-Classic

Classical reaction in architecture and decoration reached its apogee in the Queen's Dolls House by Sir Edwin Landseer Lutyens, housed in a special annex to the Palace of Arts for which a supplementary entrance fee was charged. Lutyens had become famous at an early age as an individualist in the Arts and Crafts manner of the 'nineties, designing charming medium sized country houses and gardens in close collaboration with Gertrude Jekyll. As he became older, his practice expanded from large country houses to castles, heavy stone-faced bank buildings in the City of London to the grandeur of Curzon's New Delhi. By 1924, he was the leading architect in Britain, President of the Royal Academy and Gold Medallist of the R.I.B.A.

The exterior of the Queen's Dolls House was inspired by Inigo Jones's Queen's House at Greenwich but worked out in Lutyens's own modular version of the Palladian system. Inside, every room, every detail of panelling, cornices and ceiling was designed by the architect, the furniture, glass and china made by the best manufacturers and the pictures painted by Royal Academicians; moreover, as Lutyens delighted to demonstrate to visiting royalty, the toilets really worked. It was all 'faultily faultless, icily regular, splendidly null', but constituted, nevertheless, a valuable record of the taste of the time and was the most popular exhibit in the Exhibition, even surpassing the Prince of Wales on horseback modelled to full scale in butter in the New Zealand Pavilion.

THE FRENCH SECTIONS AT THE EXHIBITION

The main ceremonial entrance was the Porte d'Honneur from the Avenue Alexandre III to the Grand Palais to the west and leading to the bridge in front. On the steps of the Grand Palais stood Bourdelle's statue 'La France', celebrating the landing in France of American troops in 1917, now in the Musée de l'Art Moderne. The bronze and wrought iron gates and grilles between piers of polished granite, low relief cast metal panels and neon-lit cascades of crystal were conceived in the grand manner of a style which became the vogue of the 'twenties, although some of the materials had to be simulated for the sake of economy. The designers were Henri Favier and André Ventre.

The Porte de la Concorde by Patout was less ornate, simpler and more architectural. It consisted of a circle of ten concrete pylons 22m high and 10m square with a single gigantic statue of a woman by the sculptor Dejean making a gesture of welcome. It was dramatic when seen by floodlight on entering from the Place de la Concorde and was greatly admired, but it was a symbolic rather than a functional gateway and did not express the idea of an entrance as well as the Porte d'Honneur. Of the twelve other entrances, that most deserving mention is the Porte d'Orsay on the left

La Porte d'Honneur

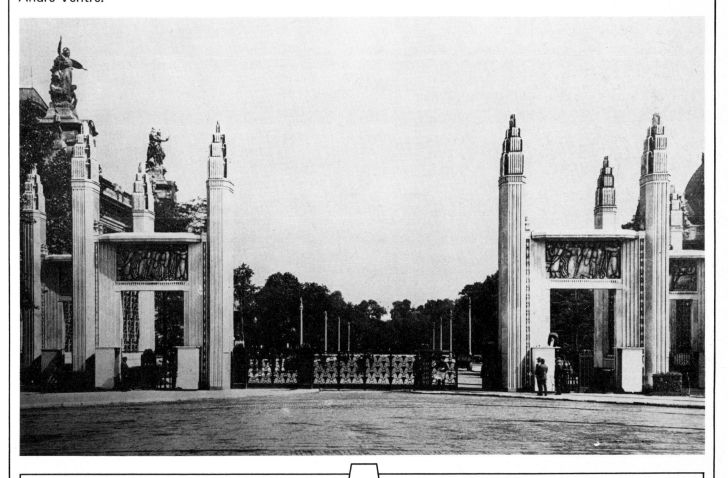

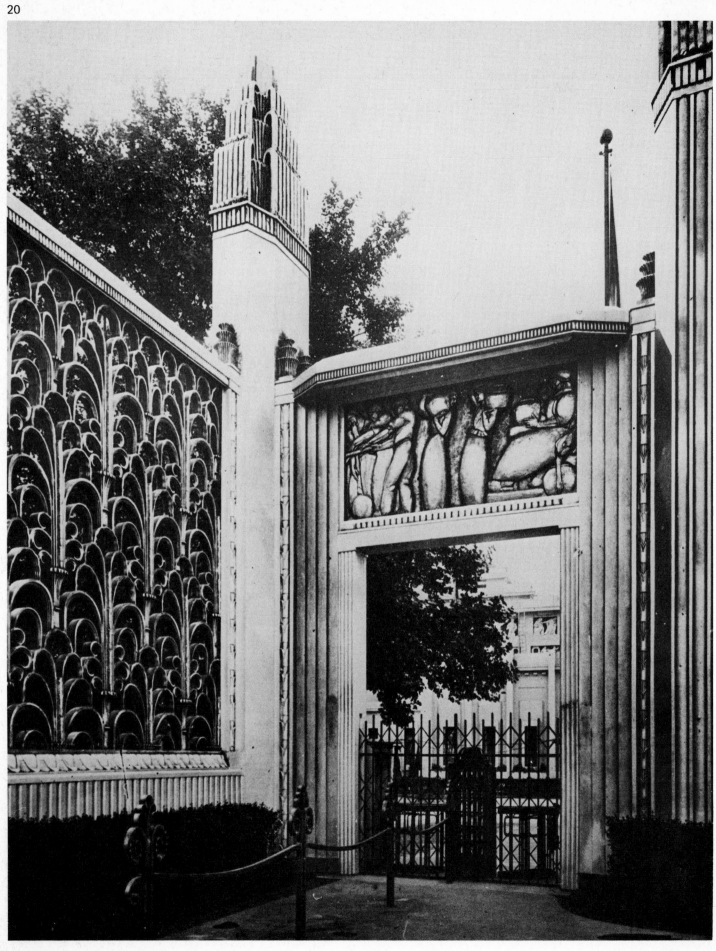

(left) La Porte d'Honneur, detail

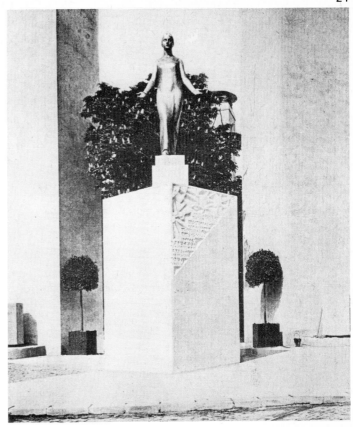

(right) L'Accueil *by Dejean in la Porte de la Concorde*

(below) La Porte de la Concorde (Patout, architect)

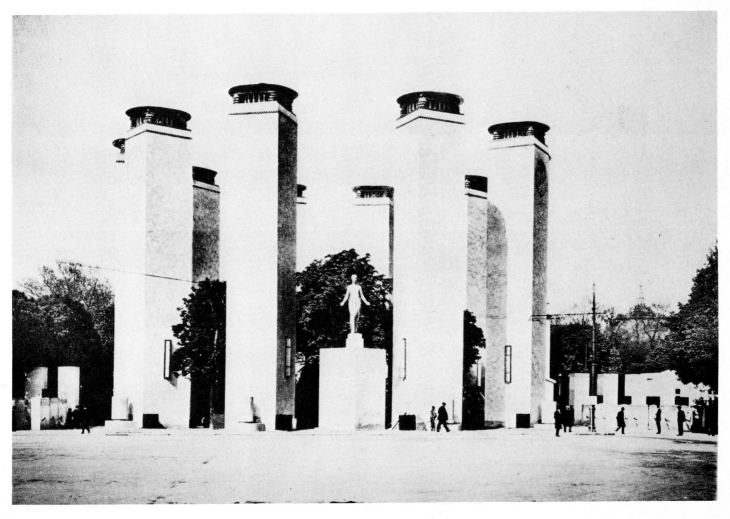

bank, with its austere steel structure and abstract
metal panel by Voquet.

The doors of the Grand Palais led to the monu-
mental Escalier d'Honneur, which occupied the whole
of the central court and was erected over a forest of
carpentry solely for the exhibition and to be dis-
mantled at its close. The Escalier ascended in a series
of recessed landings to the Salle des Fêtes. The scale
of its basically simple forms was most impressive, with
decoration in low relief and the source of both day
and artificial light concealed.

In the Salle des Fêtes decoration and architecture
were successfully co-ordinated in enormous painted
panels by Jaulmes. In the British Government's
Official Report, George Sheringham says 'fundament-
ally and traditionally, these panels by Jaulmes did not
show much sympathy with the modern movement of
painting in France, though they were broadly painted
and original in their colour scheme, which was finely
sustained all round the hall'. This chapter on mural
decoration is one of the best in the Report, and it is,
of course, correct that the Ecole de Paris were barely
represented at the Exhibition, apart from the paintings

(right) La Porte d'Orsay (L.H. Boileau, architect)

(below) Two views of l'Escalier d'Honneur in le Grand Palais
(Charles Letrosne, architect)

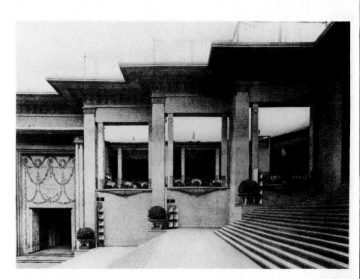

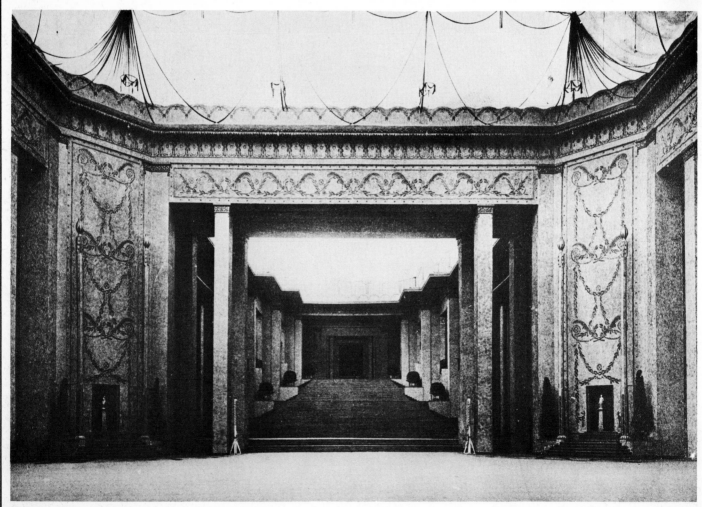

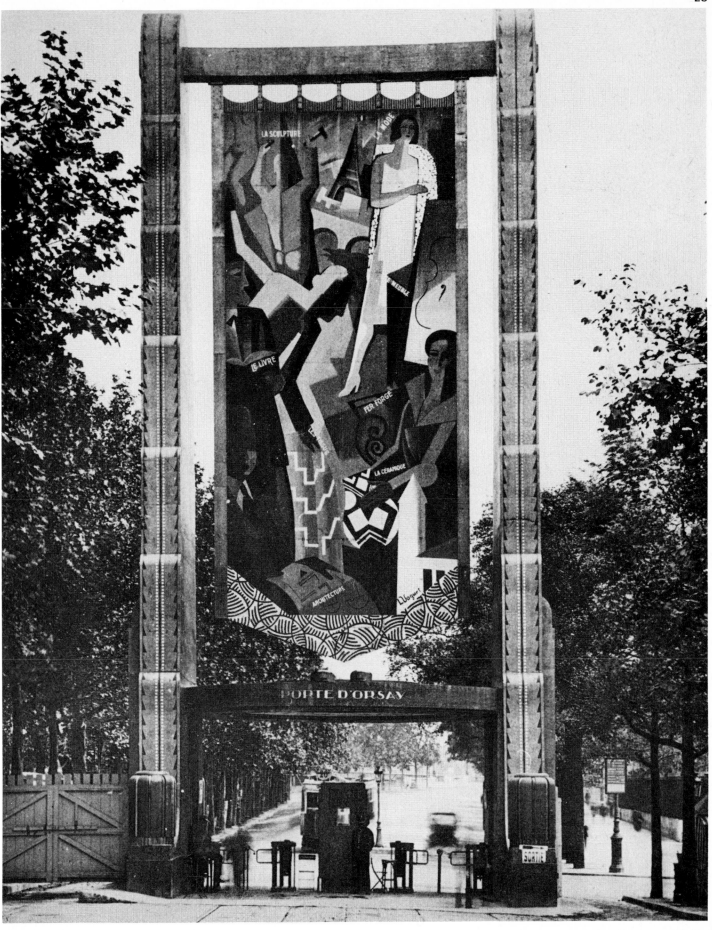

(left) Salon in l'Ambassade Française

(below) Bureau-Bibliotheque in l'Ambassade Française, composed by Pierre Chareau

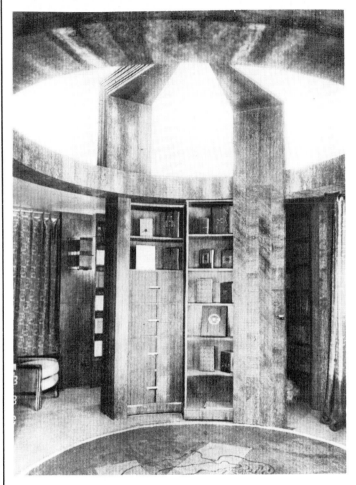

(below) Chambre de Madame in l'Ambassade Française. Panels by Marie Laurençin, ensemble by André Groult

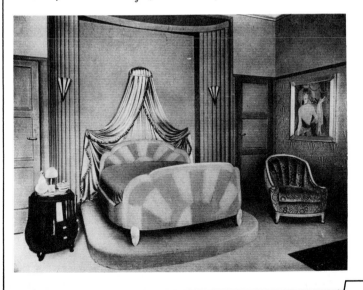

by Marie Laurençin in the 'Chambre de l'Ambassadrice' and a panelled screen in the same building.

The greatest effort was displayed in the Ambassade Française, which was produced under the patronage of the Ministry of the Beaux-Arts and occupied the most prominent site in the Esplanade des Invalides at the head of the main axis. The Embassy contained twenty-five rooms arranged around a three-sided court, the 'Galerie de la Cour des Métiers'. The controlling architects were Michel Roux-Spitz, Pierre Selmersheim and Pierre-Louis Sezille.

The rooms displayed the work of the most celebrated artists, decorators and designers. The reception rooms contained sculpture by Charles Despiau, textiles designed by Raoul Dufy, metalwork by Edgar Brandt, paintings by H. de Waroquier and lustres by Lalique. The middle of the 'U' shaped plan was taken by the Gallery of Art, designed by Michel Roux-Spitz. From a wide gallery steps led down to the Salle Landowski, containing sculpture and bas reliefs to comprise a model for a 'Temple Dedicated to Human Thought and Effort'. In the other rooms of this section were exhibited sculpture, ceramics, jewellery and goldsmith's work. Among many names now unremembered, there was more sculpture by Despiau, a silk tapestry screen by de Waroquier and drawings and engravings by Tony Garnier, who was also the architect for the Pavilion of the Lyon-St. Etienne region.

In the western wing were smaller and more intimate rooms: the bedrooms of Monsieur and Madame, who appropriately had paintings and watercolours by Marie Laurençin in a room designed by Groult; children's rooms; and a combined office library, containing sculpture by Jacques Lipchitz. This room, composed by Pierre Chareau, had plain wood panelling and considerable distinction, with a circular staircase giving access to a higher section folded up into the ceiling. The series ended with a winter garden designed by Mallet-Stevens overlooking the court and an adjoining music room.

The rooms were all completely furnished, carpeted, curtained and fitted with glass and silver tableware, ivory, jade and crystal ornaments. While the general recollection is that some of the rooms appeared crowded and over-designed, possibly due to enforced limitations of space, the ensemble represented a great and inspired effort of co-operation on the part of the organisers, the designers and the craftsmen who carried out the work. It was, at once, a not unsuccessful attempt to restore the traditional grand manner while at the same time expressing the attitudes of the era, which was one of optimism and liberation from the restraints and sufferings of the past year, deliberately irresponsible and innocently wicked.

The Cour des Métiers by Charles Plumet was enclosed by the Embassy on three sides and by a

pergola on the north, with an octagonal sunken pool and fountain in the centre. From the corners four narrow paths radiated, bordered, in the typically French manner, by dwarf box hedges enclosing geometrically planted beds. Looking to the north the view through the pergola was over the central avenue of the exhibition buildings and westward the illuminations by Citroën of the Eiffel Tower shone with ever-changing lights. The courtyard was very elegant, if rather too small in scale, particularly as the walls had carved and patterned surfaces as well as frescoes, which contributed to the fussiness of the general effect.

The importance of the site created a particular problem for the architects of the National Factory of Sèvres, Paul Patout and André Ventre, as it lay on the main axis of the Esplanade des Invalides from the Pont Alexandre III to the Cours des Métiers in a roughly central position at its point of intersection with a minor axis created by the disposition of the layout. The necessity not to block the north south vista was recognised to some degree by splitting the pavilion into two sections, with the centre point occupied by a paved court with a stepped fountain. The required emphasis was provided by four gigantic urns. The design of the pavilions was very typical Art Deco, with wide reeded pilaster strips and oval panels in low relief, contrasting with plain wall surfaces, a flat cornice and corners at forty five degrees. Much of the construction was in concrete with faience or other ceramic cladding of interesting colour and texture.

By contrast, the Exhibition Theatre, designed by A. & G. Perret and A. Granet, was an outstanding building of more than merely fashionable distinction. It was built in reinforced concrete of largely prefabricated parts, unfaced both within and without and admirably logical and straightforward in plan. Merely decorative effects were rejected, and a building of lasting quality was the result.

The Pavillon de Tourisme, designed by Robert Mallet-Stevens, was a building of great originality and simplicity and anticipated the progressive architecture of the next decade. The chief feature of an otherwise box-like exterior was the skeletal reinforced concrete tower. A continuous strip clerestory window was glazed with a cubist design expressive of the age of speed and gave an impression of landscape as seen from an automobile whizzing along at 100 kilometres an hour. Further grace was added by the symbolic relief panels by the Martels.

Four towers of similar design, greater in height than the surrounding buildings and symmetrically placed on the Esplanade des Invalides appropriately expressed the importance of French food and wine, as did the fresco by Jean Dupas in the Tour de Bordeaux.

The regions of France were represented in build-

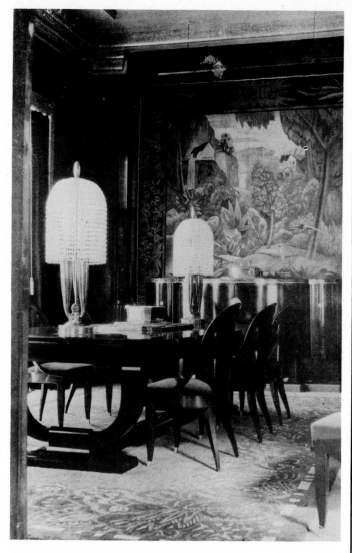

Dining Room in l'Ambassade Française

(right) The National Factory of Sèvres, behind which is one of the wine tower restaurants

ings in which the designers showed much diversity of approach. The two pavilions facing each other on the central axis of the Esplanade had some similarity, both being approximately the same size and more or less classical, symmetrical and domed; that of Lyon-St. Etienne by Tony Garnier displayed that architect's dignity and restraint but would have been grander if built on a larger scale. The interior showed a wide range of textiles. The corresponding building for Nancy et l'Est was more original. The interior of the domed hall, appropriately to the centre of the metal industries, was built of steel columns and metal plates.

By contrast, a garden represented the Alpes Maritimes. Throughout the exhibition great skill was

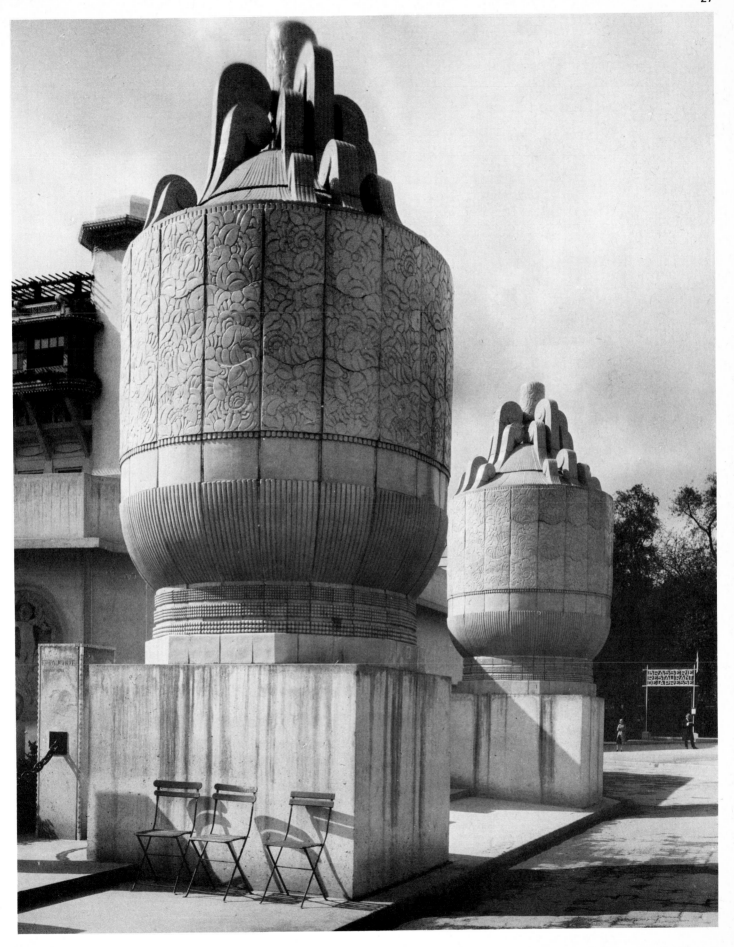

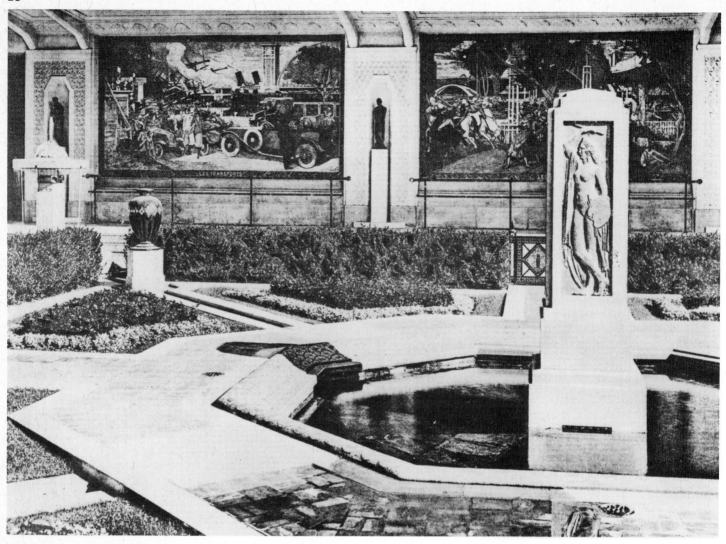

(above) La Cour des Métiers, composed by Charles Plumet

Cabinet by Ruhlmann. Amboyna inlaid in ivory

(opposite above) Dining Room in the Sèvres Pavilion
with glasswork by Lalique

(opposite below) The Exhibition Theatre

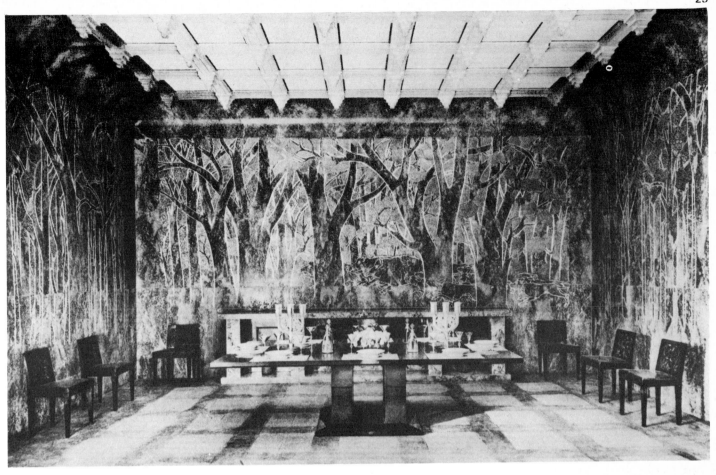

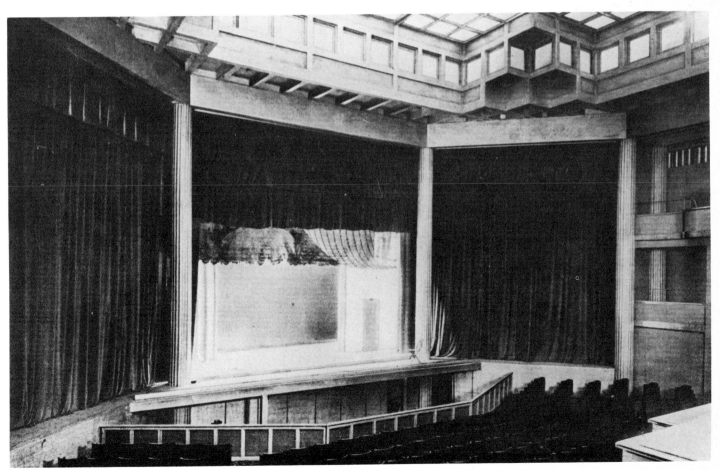

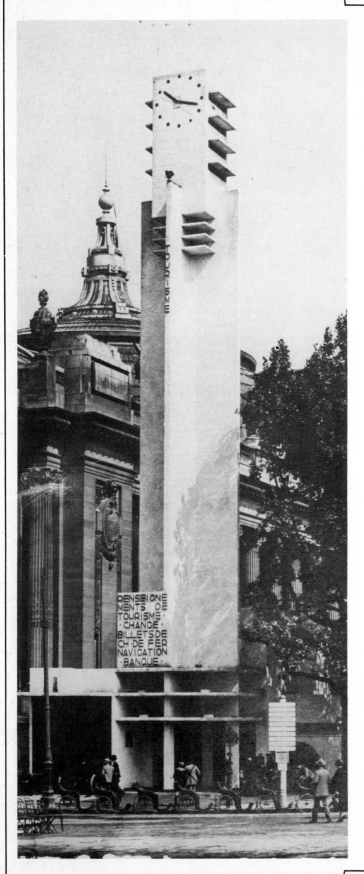

shown in the gardens, particularly those on the south bank, where all the earth had to be brought in. On the north subsoil, trees and grass were already there, and plants not normally grown so far north were aided by an exceptionally fine summer. The Pavillon de la Ville de Paris stood in a garden filling an awkward corner of the site in the north-east with a charming basin and 'allée d'eau' by Marrast. A piece of sculpture, obviously of the same period, occupies approximately the same area today and is, perhaps, a survivor. The exterior of the pavilion itself was modish, with low relief panels.

In the interior of the pavilion, an astonishingly good exhibit was produced by and for the adolescent students of the technological colleges and the children of the primary 'écoles communales'. It took the form of a miniature city centre complete with shops, theatre and school. The entire layout, down to the smallest details had been executed by the pupils including the construction, cabinet work, joinery, ironwork and electrical installations. There were examples of printing and book binding, ceramics, glass, enamels and clocks. The girls specialised in all the arts concerned with fashion, house linen or generally the embellishment of the home, including embroidery, carpet making and the production of articles in leather, ivory or bronze. In a word, all the many crafts inculcated by the academics were displayed with a high degree of virtuosity and imagination. There were designs for theatrical sets and an attractive garden laid out by the pupils of the School of Horticulture. On Thursday afternoons, normally the half holiday, students could demonstrate their skills in the little shops devoted to their trade, and even the infants, four to seven year olds, showed their budding craftsmanship in toy making, weaving and the like. All this did not, naturally enough, reflect existing conditions in all schools, but it was a demonstration of what was possible to achieve and of what fresh, young minds, encouraged and uninhibited could accomplish given the right conditions.

Provence was represented by a typical Mas, Normandy by a Clos, Franche-Comté, Berry, Mulhouse and Alsace also by more or less traditional buildings and exhibits. In the 'typical modern French village', however, the Town Hall was designed by Hector Guimard but displayed little of the pioneer spirit of his Paris Art Nouveau Metro stations. Exhibits from l'Afrique du Nord and Morocco were housed in separate pavilions. Frescoes by Sureda, the

(left) Le Pavillon de Tourisme, in the background of which a corner of the Italian Pavilion and le Grand Palais can be seen

(opposite above) Interior of le Pavillon de Tourisme

(opposite below) The Alpes-Maritimes garden

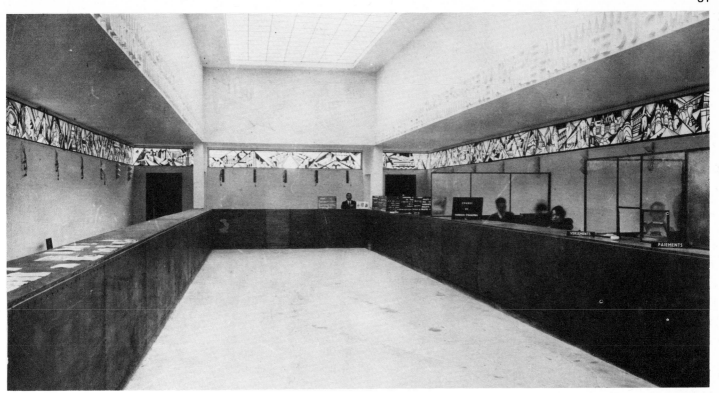

32

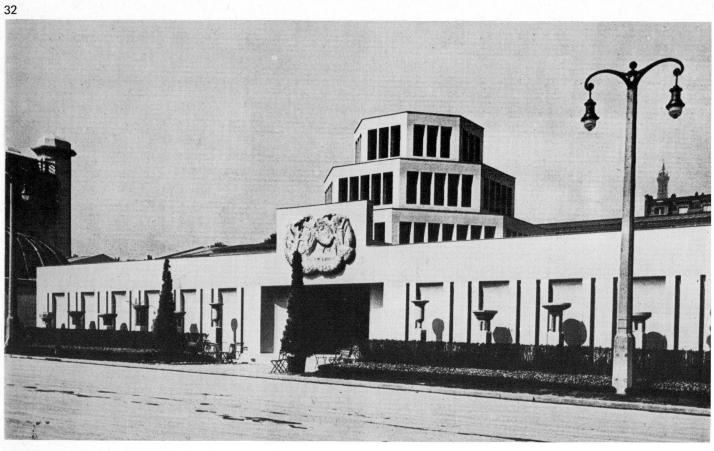

Le Pavillon de Lyons-St. Etienne and a view of its interior (below) with an appropriately splendid display of textiles

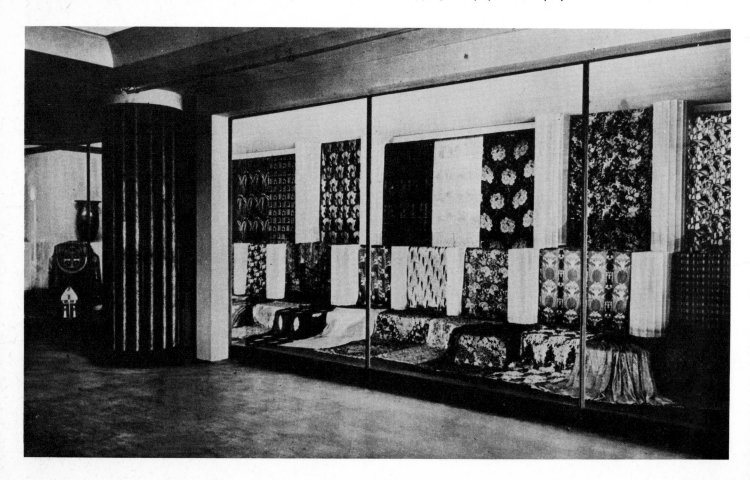

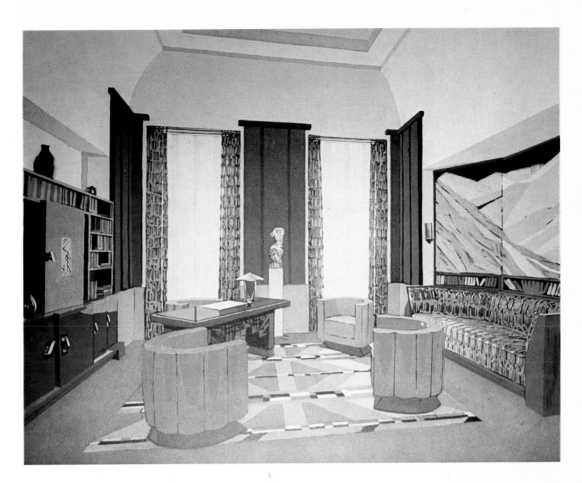

Bureau by Djo Bourgeois for
Studium Louvre

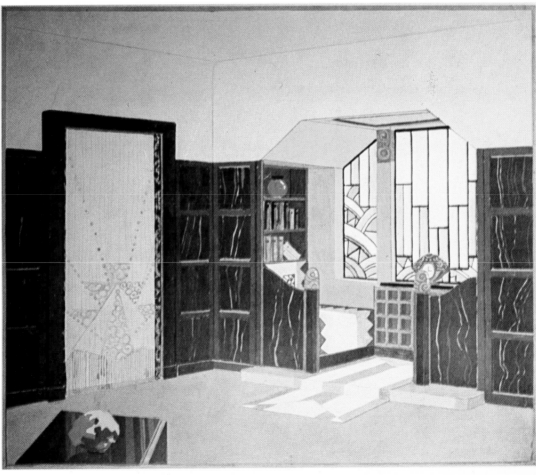

Cabinet de travail by Eric Bagge

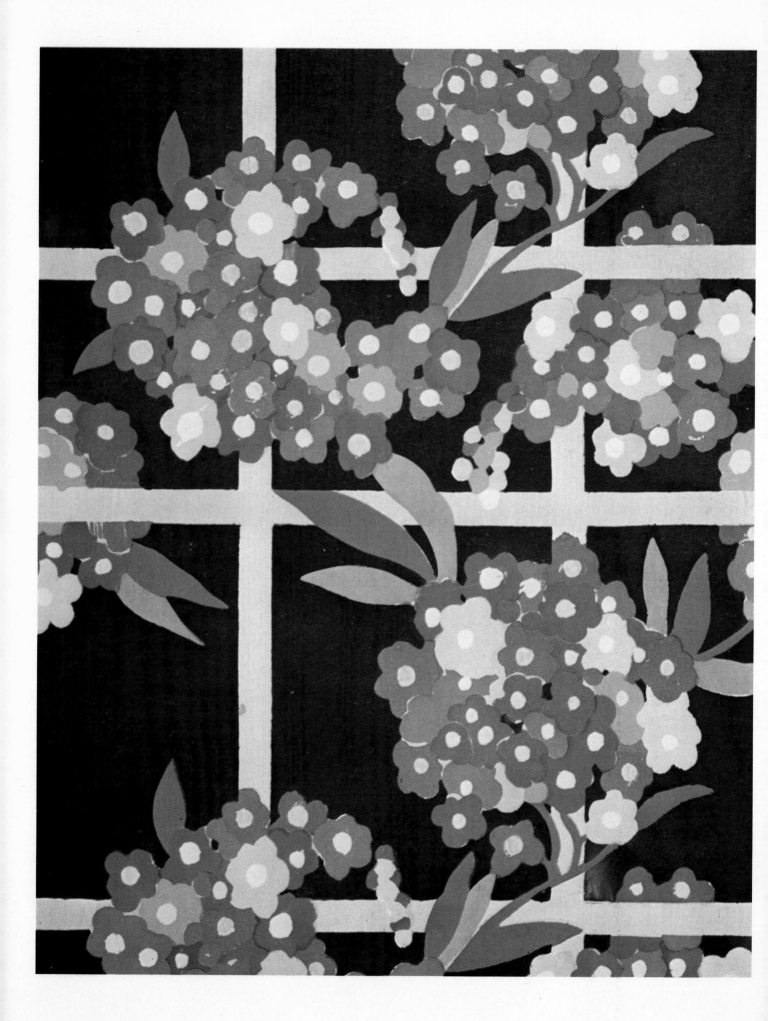

buildings by Germain Oliver, Laprade's new native village for Casablanca and the Tunisian bazaar all showed sympathy to indigenous character in varying degrees.

One of the buildings most admired both by French and foreign visitors was the elegant and refined Pavillon d'un Riche Collectionneur, built for Ruhlmann by Pierre Patout. The garden front was surmounted by a saucer dome and had three tall windows which looked on to a prize winning sculpture group entitled 'A la Gloire de Jean Goujon', standing on a lawn. The whole ensemble had the chic of the period at its best, with a flavour of Louis Seize, more than of the sixteenth century.

The interior contained Ruhlmann furniture of a most luxurious and expensive type, made of exotic woods and intricately inlaid, with curved outlines predominating. 'Les Perruches', a painted panel by Dupas, with its well organised composition of formalised tubular female forms expressed 'luxe, calme et

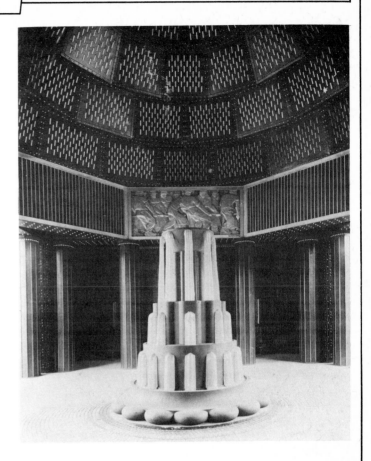

(left) Begonias, *a wall paper used on* Amours, *the barge decorated by Martine*

(right) *The entrance hall in le Pavillon de Nancy et L'Est, showing the influence of the iron and steel industries*

(below) *The forecourt and entrance of le Pavillon d'un Riche Collectionneur*

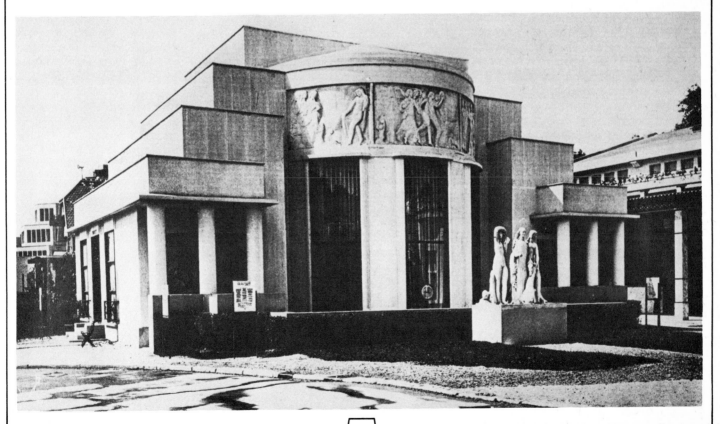

Bureau de Dame in le Pavillon d'un Riche Collectionneur

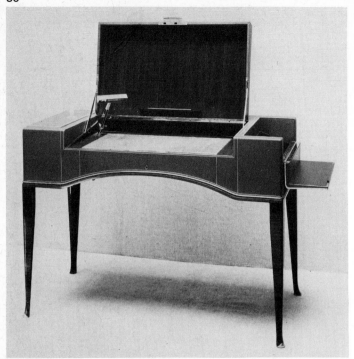

Garden front of le Pavillon d'un Riche Collectionneur

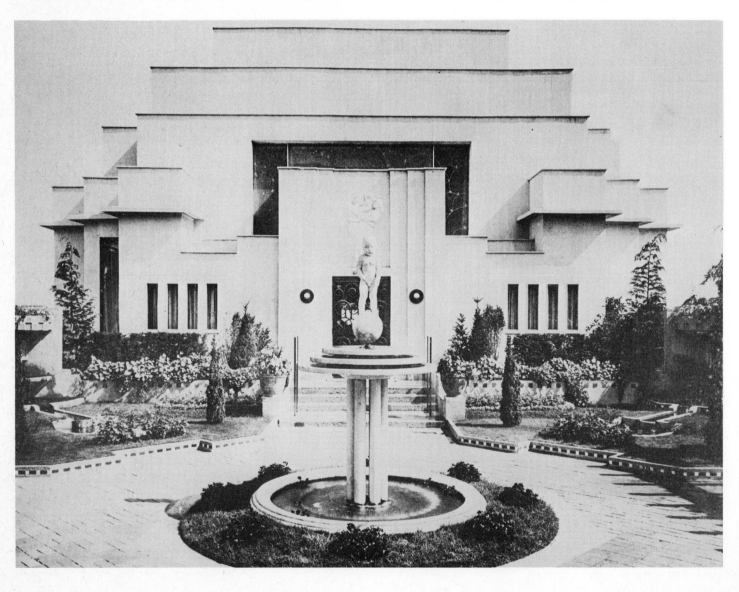

volupté' to a public not yet ready for Matisse. Dupas was a decorative painter whose work showed some similarity to that of the mannerist Jean Mignon. This panel stood over a fireplace of heavily figured marble which continued around the painting as a frame. The surrounding wall was covered with an intricately patterned fabric by Stephany, and the carpet carried a decorative design. The whole effect was rather overpowering and contrasted with the work shown by that of the Scandinavian countries, which understood the value of simplicity.

Of almost equal prominence on the Esplanade was the Lalique pavilion, naturally exploiting to the full the use of glass, with yet another fountain, in the form of an obelisk, which was very effective when illuminated at night. Lalique also displayed a dining room in the Sèvres pavilion where the top lit room was cased in walls of inlaid glass mosaic. In fact, Lalique glass, together with decorative metalwork by Brandt, pervaded the French sections and, to most people, typified the style of the period.

Four pavilions, symmetrically placed and of similar shape and dimensions, although different in architectural treatment and planning, represented the department stores of the Louvre, Galeries Lafayette,

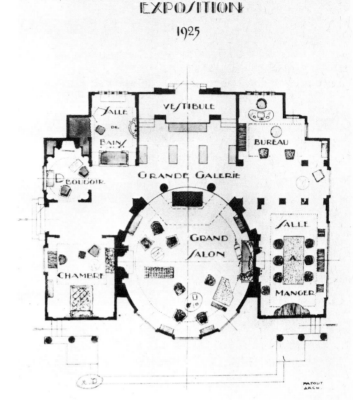

(right) Plan of le Pavillon d'un Riche Collectionneur

(below) Pavilion exhibiting the wares of Baccarat and Christofle

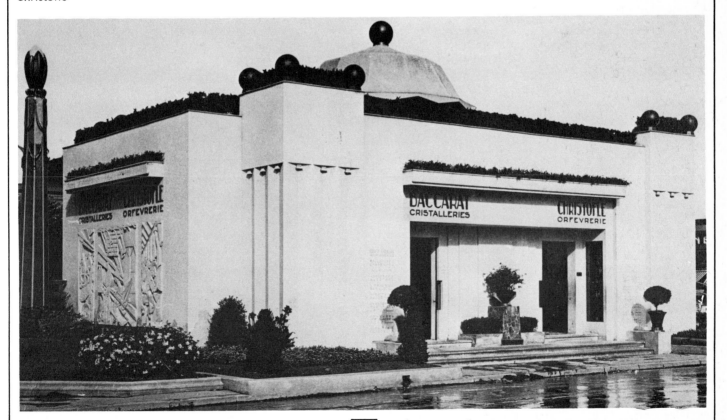

Printemps and Bon Marché. The interiors of these pavilions showed that 'modern' furnishings were accepted by the popular taste of France in 1925, whereas at the same time in England, they were hardly known. British attempts at innovations in the early years after the war, such as Roger Fry's at the Omega workshop, had not succeeded.

The interior displays of the Pavilion of the Galeries Lafayette were designed in their own studio, known as La Maîtrise, under the direction of Maurice Dufrêne. The architects were J. Hiriart, J. Tribout and G. Beau. Externally, it gave a charming expression with its 'Quartres Petites Terrasses Fleuries' on the first floor, while inside 'La Vie en Rose' was expressed with consummate skill in the Chambre de Dame. Undulating lines culminated in the capacious bed standing on a dais guarded by a rail, the windows net curtained and draped. Curved forms were everywhere. A polar bear's skin extended on the floor symbolised the male beast, the gaping feral jaw restrained by a tasselled silken cord. The lighting was discrete and indirect, embodied in the pelmets, coved ceiling and alcoves but spreading evenly a high degree of luminosity. The dominant note of colour was, of course, rose, contrasting with the silver and black marble tops and with the furniture, mostly kidney shaped in lemonwood and maple. This room presented the quintessence of the exhibition and indeed

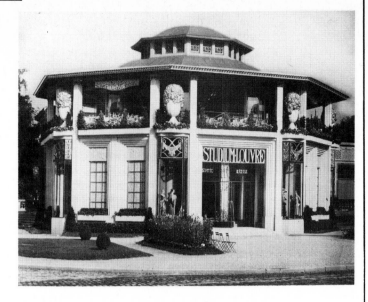

The Studium Louvre Pavilion, with detail (right)

(below) Fountain, by Lalique, standing before the colonnade of l'Ambassade Française

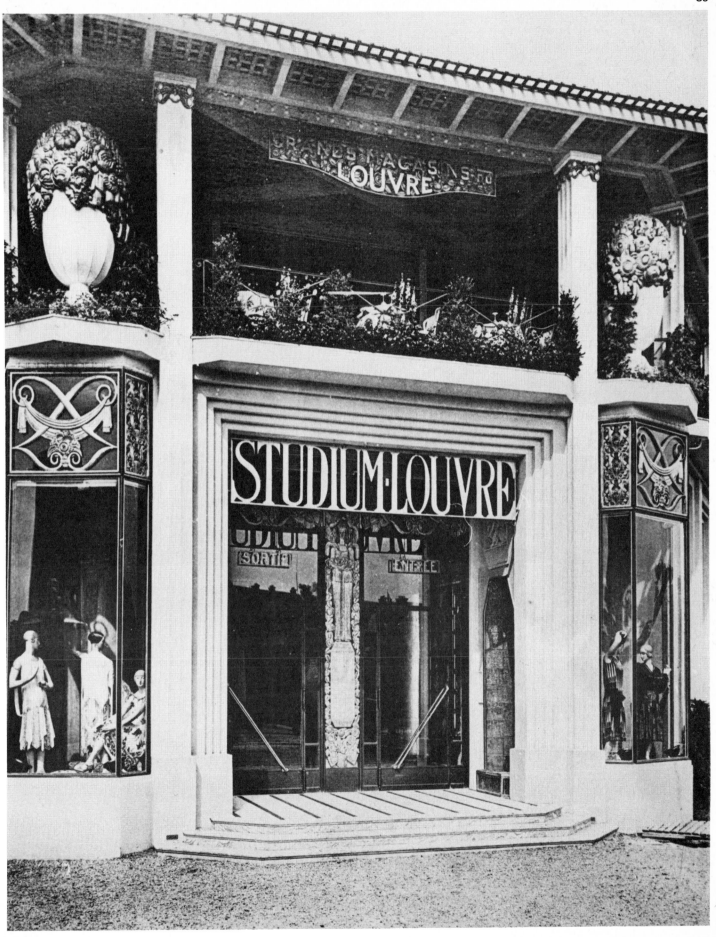

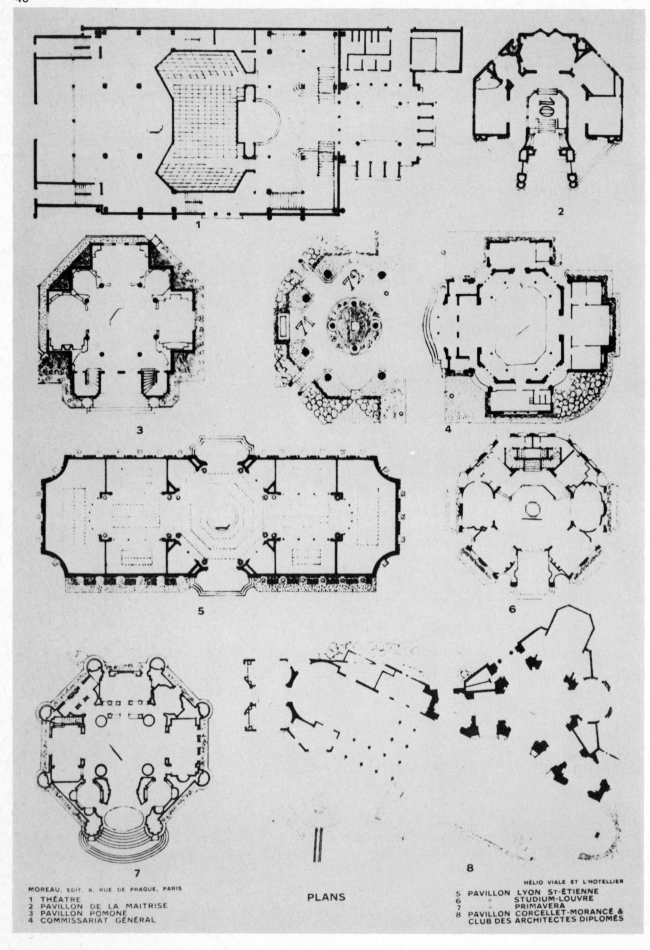

PLANS

HÉLIO VIALE ET L'HOTELLIER

1 THÉATRE
2 PAVILLON DE LA MAITRISE
3 PAVILLON POMONE
4 COMMISSARIAT GÉNÉRAL

5 PAVILLON LYON ST-ÉTIENNE
6 " STUDIUM-LOUVRE
7 " PRIMAVERA
8 PAVILLON CORCELLET-MORANCÉ &
 CLUB DES ARCHITECTES DIPLOMÉS

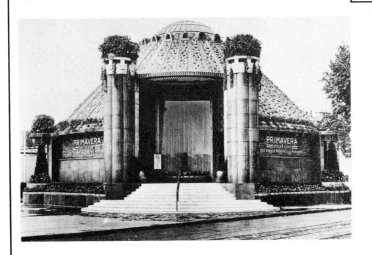

The Primavera Pavilion

(left) Plans of various buildings in the Exposition

The Bon Marché Pavilion

of the period.

Although none of the other three department stores achieved quite such a tour de force all made distinguished contributions which will be dealt with in more detail in the next chapter on the art of the ensemble and its components. The Magasins du Printemps with the work of their studio, Primavera, were housed in an interesting building by Sauvage with a hyperbolic concrete dome encrusted with small circular pieces of glass. In contrast, the Bon Marché pavilion by Boileau was more rectangular and almost monumental. The director of Pomone, its studio, was Paul Follot. The charming and decorative pavilion of Studium Louvre by Laprade contained a well designed study by Djo Bourgeois and a distinguished bedroom by Etienne Kohlman.

As is best illustrated by the plans, these four pavilions all were designed to the same building programme, occupying a similar area of ground and approximately the same height. Each architect, however, met the requirements in an entirely different way and asserted the liberty from classical conventions that the new style had introduced.

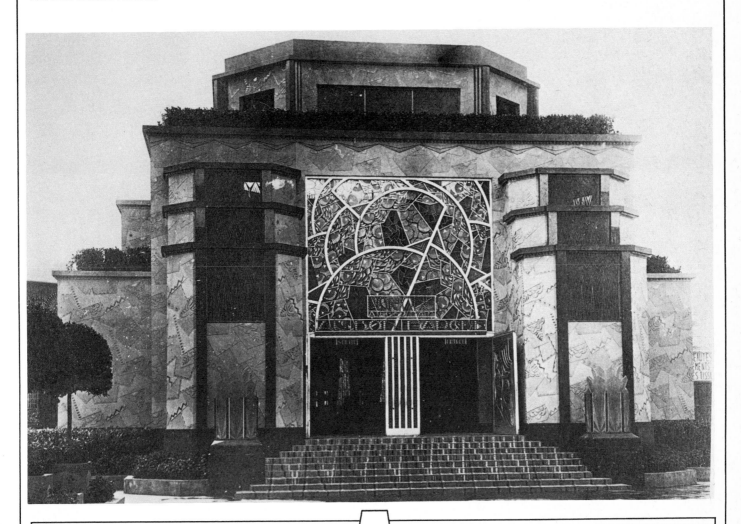

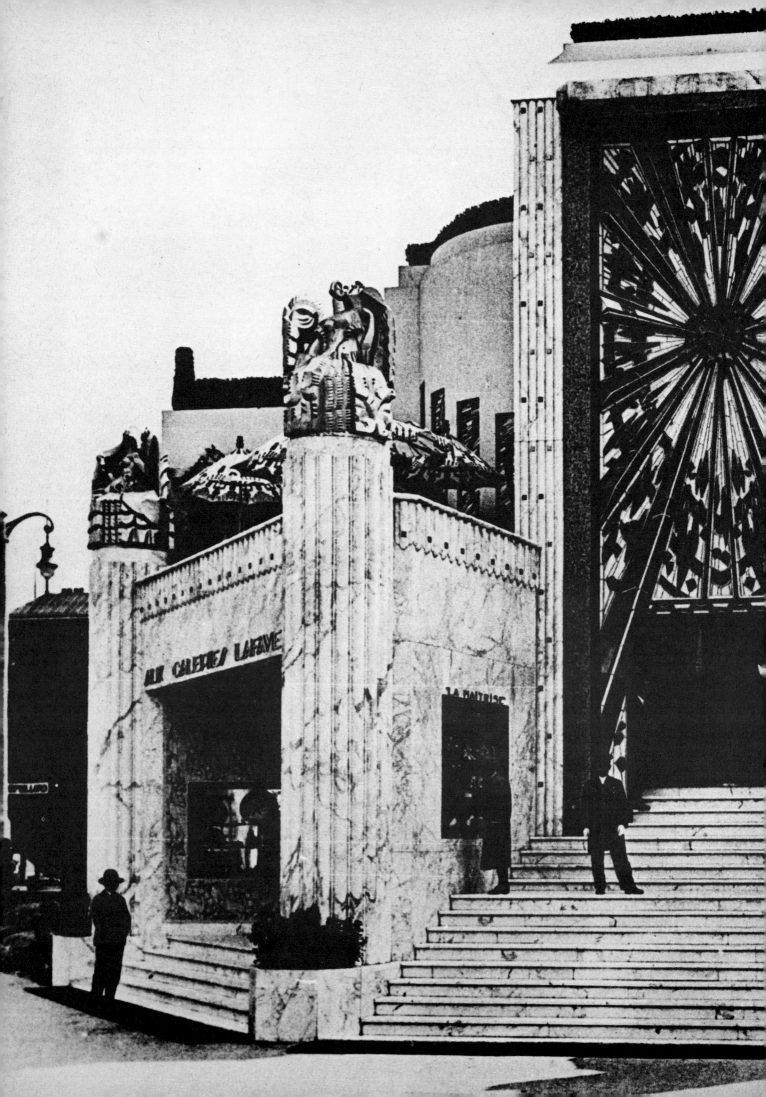

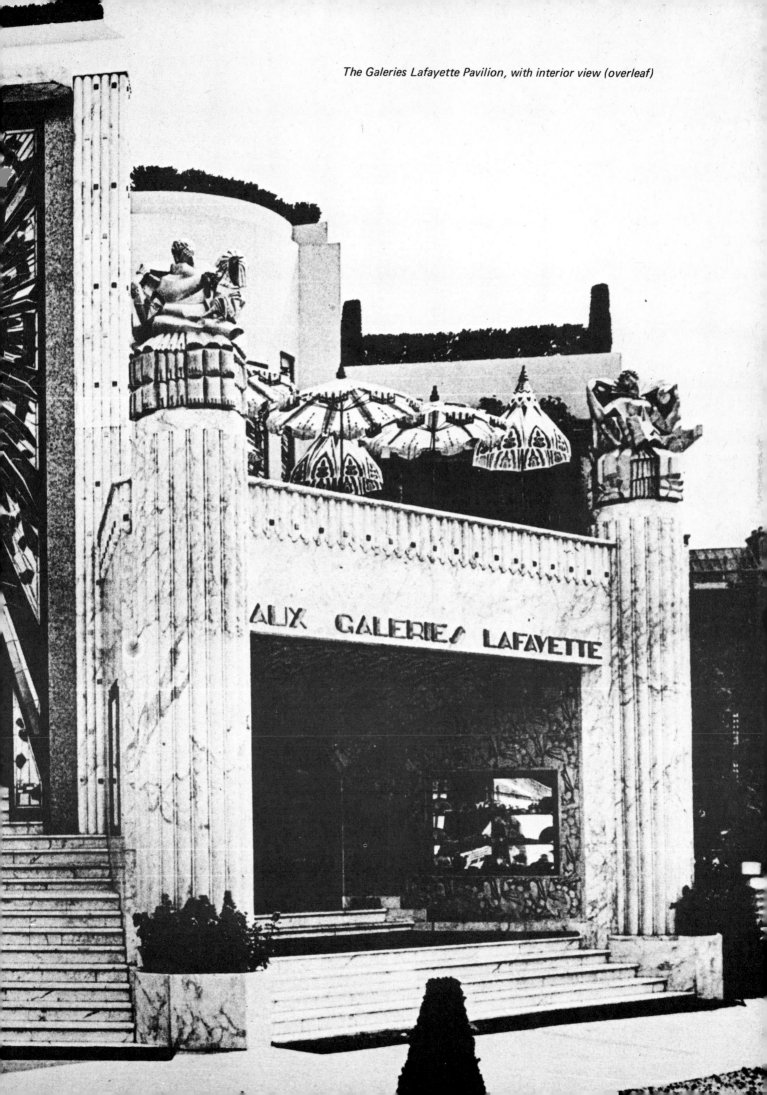

The Galeries Lafayette Pavilion, with interior view (overleaf)

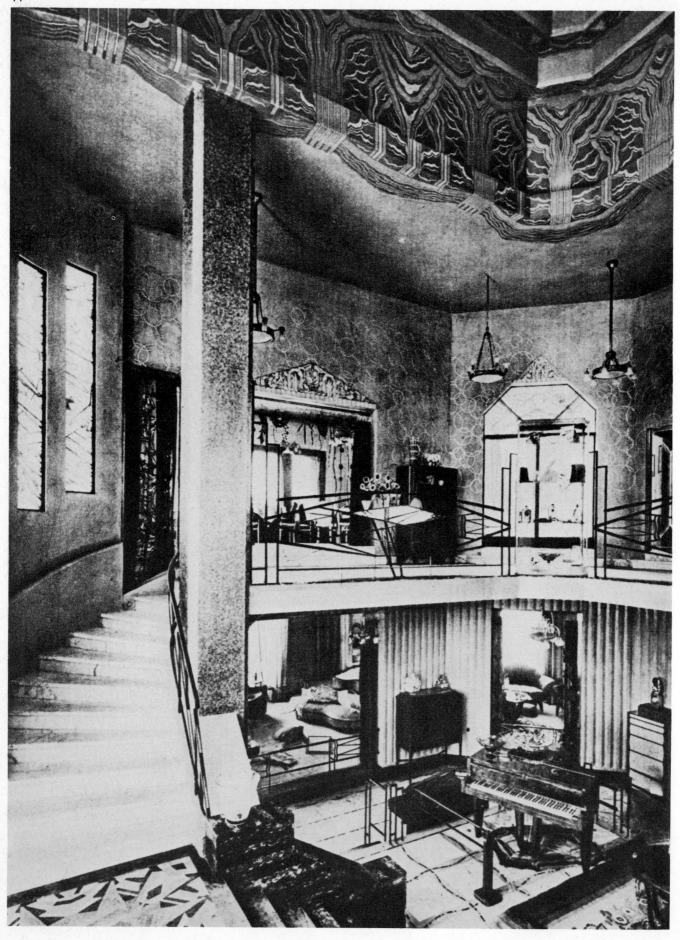

FRENCH DECORATIVE ARTS

The Ensemble

Any attempt to convey the flavour of the culture of a past generation to those who did not experience it is extremely difficult, especially, one might add, if that culture precedes an era of as great social change and rapid development of applied science as ours. The character of Art Deco, as it has come to be known, derived from Art Nouveau, not as a continuous development but more in the nature of a rebirth after the first World War and its aftermath. Possibly, that generation had had its fill of misery, devastation and austerity and turned to the colour and luxury of the decorative arts as a form of escapism. Be that as it may, some great creative artists found in Art Deco a satisfying form of expression. Reaching its highest point in 1925, this style was almost baroque in its character of luxury and brilliance and appealed, undoubtedly, to the new rich who had emerged with developing industrialisation. The coming of the depression introduced an economic factor which favoured 'De Stijl' rather than Art Deco and this emergence of a new aesthetic that was more architectural, austere and intellectual culminated in the teaching of the Bauhaus. Nevertheless, Art Deco has played a very significant part in the development of the decorative arts in this century, and its influence is apparent today especially in textile design, glass and ceramics.

It was the creators of Art Deco who conceived of a room as being a harmonious whole in which each object, furniture, hangings, glass, china or paintings and sculpture, contributed a significant part to what was a carefully designed work of art. Although the eighteenth century and the age of neo-classicism were admired for their comfort, dignity and elegance, a new age demanded self expression and not historicism which had turned sour with constant repetition. The distinction between the so called fine and the applied arts was viewed as invalid by those who felt that the aesthetic revolution that had occurred in painting and sculpture should find its parallel in the arts of design. As with the painters and sculptors, the decorators had struggled against tradition and prejudice, but, finally, more fortunate than the former, they found,

in France, at least, a champion in the state, who saw a financial stimulus to the output of the nationally owned factories and an expression of national pride and renewed vigour in a display of skills and creative design. This was the foundation of the 'Exposition des Arts Décoratifs et Industriels Modernes' of 1925.

Again, we are apt to think of Art Deco as an isolated phenomenon of the inter war years. In fact, not only was it the result of research and of clear, logical thinking but also, as with De Stijl, it became the basis of contemporary design. The daring colours, the stylised decoration, the clean outlines, the architectural forms are all there. Perhaps, as we literally have the artistic riches of the world to draw on, we have learnt to marry motifs from many ages and places to our present day needs, but our debt to those pioneers of half a century and more ago is obvious. Perhaps the architectural forms which Van Doesburg, Rietveld and the others evolved from steel and concrete and applied to the interior furnishings was not really revolutionary in principle. It was the difference in material and the changed structural exigencies that caused the upheaval and led to a new dimension in design.

The Grand Palais was built for the Exhibition of 1900. Triumphantly florid, it is eminently suited to its purpose of display. On one occasion, an official showed me the way up to the domed roof and how to climb to the top by means of the hand holds. I (M.T.) stood behind the great quadriga at the angle, a position hardly visible from below, and had a magnificent view not only of the gleaming pavilions and palaces of the Exposition but also of the great panorama of Paris from the Sacre Coeur at the summit of Montmartre to Notre Dame and beyond with the winding river and the graceful bridges that span it.

Through the main entrance to the Grand Palais, one normally entered a vast arena, which, during the annual Salon des Artistes Français, the official art exhibition, contained a veritable sea of sculptured figures in marble and bronze. For the most part, they were highly competent but traditional in character. Needless to say, the 'moderns' exhibited elsewhere. I have often wondered what has happened to them all for their output was tremendous. All

this was changed, however, for the 1925 Exposition. The architect, Charles Letrosne, had devised a magnificent Salle d'Honneur and wide central staircase, certainly one of the most successful constructions in the whole Exposition. Though owing something to tradition, it was pure Art Deco in spirit, combining simplicity with a grandeur of proportion that was truly impressive. At the end, in October of that year, it was the scene of the ceremonial presentation of awards by the President of the Republic. The choir and orchestra of the Opéra thundered forth *La Marseillaise,* and each commissioner representing the foreign countries and accompanied by a standard bearer proceeded down the great staircase to accept the awards. All the standards were lowered in salute, all, that is, except the red flag of the USSR, an ill mannered gesture that the press wisely chose to ignore. Then followed the speeches and the statistics. It was a success story. The receipts had exceeded the expenditure, and the main object, that of giving a fresh impetus to the contemporary arts of design, had been achieved.

Before attempting to describe the various categories of contemporary art involved, let us look again at the art of the 'ensemblier' on which so much stress was laid. Ephemeral as its achievements must be, this skill is basic to all interior decoration. It is the concept of composition applied to the arrangement of the interior spaces of a building and involves the consideration of the uses to which these spaces are to be put, the relationship to each other and to the space of the three dimensional objects that are to be placed therein. There are considerations of texture and character and the skill of a painter is required for the juxtaposition of colours, the understanding of the qualities of the objects to be used, the effect of lighting and the perspectives created from different angles. Finally, the elements chosen, when removed from their context, should still have an intrinsic value of their own.

It was with this in mind that so many of the exhibits took the form of fully furnished rooms though the principles involved were, of course, equally valid for specialist displays. After fifty years, it is hardly surprising that a detailed description of these exhibits cannot be attempted from memory alone, although recourse to the many photographic records that were made does much to fill in the gaps. It is unfortunate that in 1925 the techniques of colour photography were relatively undeveloped and the quality of this essential element is, therefore, difficult to evoke. Although conceived within the broad framework of the evolving style, naturally enough, they displayed the individual characteristics of their creators. I say 'naturally enough' although this was not the case with De Stijl whose aim was complete unity in the new idiom.

Art Deco is often described as being elitist, and this is true of certain designers, particularly those like Ruhlmann or Dunand, who created unique pieces for the connoisseur and used the most expensive materials and methods. It must be remembered however, that these were not the days of mass production by highly sophisticated machinery. Experiments had to be made and finished models produced before a 'style' could emerge that was fit for general application. Paul Follot is quoted as affirming that 'this elite is one mind and heart, of sensibility and culture who come from every class of society'. Moreover, it was the less well off who demanded luxury, the wealthy inclined to greater simplicity. Certainly the Art Deco ensembles had an effect of sumptuousness, a characteristic not always to the taste of the countries of northern Europe or of Britain, usually more puritan in outlook and whose thinking evolved more on 'fitness for purpose' lines. However, one suspects that this is a recurrent phenomenon; to every Abbot Suger there succeeds a St. Bernard wagging an admonitory finger.

These ensembles were displayed in the various pavilions erected for the exhibition in collaboration with their architects. The Ambassade, produced under the aegis of the Ministry of Fine Arts, Ruhlmann's 'Pavillon d'un Riche Collectionneur' and the Lalique exhibit have already been described and allusion made to the pavilions of the Parisian department stores, Primavera (Printemps), Pomone (Bon Marché), La Maîtrise (Galeries Lafayette), Studium (Louvre). These 'ateliers' and others were under the direction of experienced decorative artists aided by a team of specialist designers, and the work was carried out by craftsmen in state and privately owned factories. Rather than to catalogue the exhibits, however, it is more interesting to recall some of the principles enunciated by their creators. Maurice Dufrêne was the director of 'La Maîtrise'. He was one of the slightly older generation, as were Follot, Lalique and Poiret, who had served their apprenticeship in the pre-war days of Art Nouveau. Something of its sinuous lines remained in his technique as may be inferred from his magnificent 'Chambre de Dame' and other works. He is insistent on the difference between applied decoration and design intended for flat surfaces such as textiles and wall coverings, between work produced, on the one hand, essentially from the drawing board and for which little knowledge of manufacturing techniques is required, where fantasy can be given full play, and, on the other, the serious business of constructing furniture. 'A cabinet maker is an architect' and not a mere decorator. 'In designing a piece of furniture, it is essential to study conscientiously the balance of volume, the silhouette and the proportion in accordance with the chosen material and the technique imposed by this material.' Ornamentation was secondary. 'The style of a cabinet is in its character, in its soul—since things

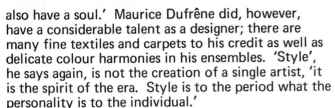

also have a soul.' Maurice Dufrêne did, however, have a considerable talent as a designer; there are many fine textiles and carpets to his credit as well as delicate colour harmonies in his ensembles. 'Style', he says again, is not the creation of a single artist, 'it is the spirit of the era. Style is to the period what the personality is to the individual.'

A very recognisable style was emerging indeed in the France of the 'twenties. Typical were the curved backs of armchairs and occasional chairs and the tapered and reeded legs. Heavier furniture had usually solid rounded or conical supports or rested on plinths plain or with reeded decoration. Motifs in carved wood or inlay were frequently used, but, generally speaking, the accent was on simplicity of outline and the natural beauty of the wood. Burrs were frequently used, the high polish emphasising the pattern of the grain and in addition to the usual hardwoods, mahogany, walnut and oak, use was also made of ash and maple, rosewood, amboyna, cherry, ebony, and many others. It had always been traditional in France to use linens and brocades as wall coverings, and this was continued to good effect, the colours and textures providing a suitable background to the furniture.

In 1923 Léon Riotor wrote a monograph on Paul Follot, one of a series produced under the aegis of the Ministry of Fine Arts concerned with contemporary decorative artists. He has much of interest to say on the development of the applied arts and insists on the right of the decorator to an equal status with the painter, sculptor and architect, being equally subject to a severe discipline in order to achieve mastery in his craft. He similarly is concerned with technical problems, with mass, contour, line and colour. He must understand all the different skills and, as with the conductor of an orchestra, the ensemblier must comprehend every note in the symphony. Paul Follot was a lecturer and instructor in the official school of decorative art and had a very considerable

Chambre de Dame in the Galeries Lafayette Pavilion

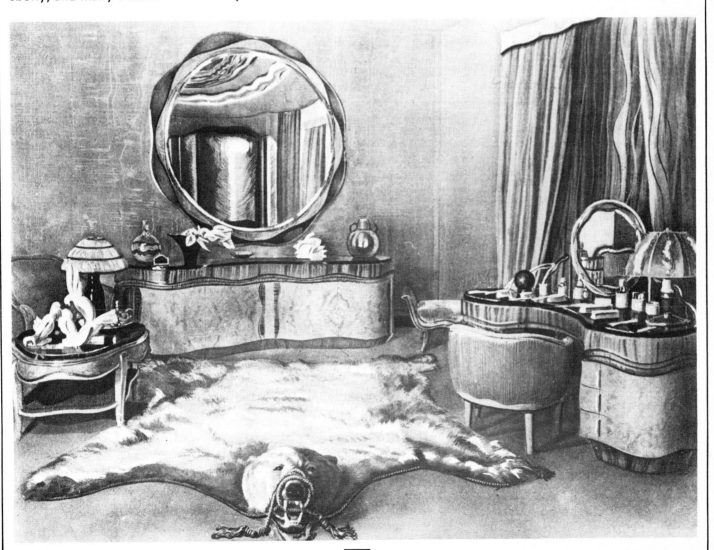

influence in this connection on the thinking of his time. The pupils received both a thorough grounding in all the essential techniques and an understanding of past styles. The greatest tradition inherited from the past, he asserts, is that of creating and not of copying. 'I think that in every true work of art, there are two elements: one, common to all men and to all epochs and which will forever be universally comprehended; the other, peculiar to an individual or a people, especially expressive of sensibility at a given period; it is this second element that gives to the work, in contrast to the others, its strength and charm, its inimitable savour.'

In 1925 Paul Follot was the director of Pomone. Its pavilion, designed by the architect L.H. Boileau, occupied a favourable site on the Esplanade des Invalides and to the left of the main avenue leading from the Pont Alexandre III. A square marble basin in the centre of which rose a fountain springing from

Escritoire and chair in an English country house

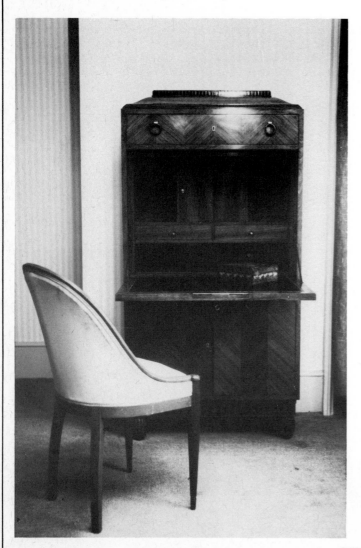

a 'vasque' of golden mosaic occupied the middle of the entrance hall. Illuminated showcases displayed ornaments, pottery and porcelain designed in the Pomone workshops. Around and on the upper floor were the rooms or ensembles created by Follot. These consisted of furniture of rare woods but comparatively simple outlines, sober colours and diffused lighting, rich Savonnerie carpets, damask wall hangings and, as a whole, gave an impression of controlled splendour.

Not far away, on the opposite side of the Esplanade, the octagonal pavilion designed for the Studium had been erected. Several notable designers were concerned with this, among them Fréchet, Lahalle, Levard, Matet and Djo Bourgeois. The last named's study gave us a foretaste of things to come with its semi-cylindrical chairs upholstered in scarlet leather and the geometrically designed carpet in orange, black and white. Laprade, the pavilion's architect, also designed a bathroom built entirely of moulded glass tiles by the master craftsman, Daum.

A number of different artists were also concerned with the products of the Atelier Primavera. There were some delightful ensembles by Lucie Renaudot and Madame Chauchet-Guilleré, but perhaps this studio is remembered mostly for the quality and particular character of the accessories, in particular the pottery, textiles and wrought iron. Primavera certainly became a household name for such things at this time and undoubtedly contributed a great deal to the development of the public's taste for 'l'art moderne.'

There were, of course, many other 'ensembles' worthy of note in the hundred or so French pavilions. The firm of Suë et Mare, for instance, produced masterly pieces that bore comparison with work by Ruhlmann or any other of the leaders in this field. Their designs were characterised by a combination of strength and grace, allied to first rate craftsmanship. Then there was the work of Leleu, also a master craftsman, Léon Jallot, René Joubert and others. Many of these designers experimented successfully with furniture to be produced 'en série'. Though this did not then have the meaning of mass production as we know it today, it did, at least, mean the repetition of models in sufficient numbers to allow a reasonable reduction in price. This, along with so much else of value, was to be jettisoned by the slump that followed in four short years.

Poiret's three barges, christened 'Amours', 'Orgues' and 'Délices', were anchored on the south bank, to the west of the Pont Alexandre III. Though he had considerable influence on the taste of his time, Poiret is not to be considered as an interior decorator in the strict sense that we have been discussing the art. His genius lay rather in the creation of costumes, both for fashion and the theatre, with a side glance at the setting of his showrooms, the design of textiles,

carpets and cushions. Everything has antecedents, and it is impossible to be dogmatic as to where anything began or ended, but one can say with truth that Bakst and Poiret opened our eyes to the enormous and emotive power of colour in everything that concerned design.

Design in the Decorative Arts

Aesthetics presented a curious paradox. 'If only we could return to simplicity' was the cry. 'If only we had the vision of a child or a primitive man. If only we could forget the teaching of the academies and look at nature and art uninhibited by the accretions of the past.' To be sure, the Victorian and Louis Philippe knicknacks disappeared, and 'trompe l'oeil' art was scorned and discarded, but what replaced them was far from simple or naïve. Art Deco was highly complex and what succeeded it was highly intellectual and sophisticated. It is not certain if there is any conclusion to be drawn from this but at any rate the battle against mindless repetition had been won and won handsomely.

This is not the place to discuss the technicalities of textile manufacture. It is important to note, however, that in the period with which we are dealing very little in the way of man made fibres, apart from artificial silk, was in commercial use. For the most part, stuffs were woven of pure silk, wool, linen or cotton. The 'lamés', which were so popular for evening dresses, were interwoven with real gold or silver thread, not with the 'lurex' with which we have become familiar. Fine and durable fabrics were produced at what today we should consider extremely reasonable prices, while, on the other hand, 'drip dry' and creaseless materials had yet to come.

It is interesting to speculate on what exactly gave to French design the special character it had assumed by 1925. Searching for who did what first would probably be useless and misleading, although the work of Poiret's Ecole Martine would not be a bad starting point. Reference has been made already to the search for what was called 'naïveté', and Poiret's idea of using the imagination of unschooled young girls to produce fresh 'motifs' from natural forms was a genial one, in keeping with the movement for liberation from past restraints. These fresh ideas were then worked on by artists of distinction, Raoul Dufy, Dunoyer de Segonzac, Van Dongen and the rest. The war interrupted this experiment, but the lesson had sunk in and, after 1918, gained a strong momentum. Poiret himself was primarily a couturier and looked for and achieved in all he did the indefinable quality of 'chic'. 'Ça, c'est chic', a phrase so often heard, apparently needed no further explanation.

By 1925, as far as the French public was con-

cerned, Art Deco was a recognised form. It is possible that its success in France as opposed to England rested on a psychological difference of approach. Artists in whatever medium, if not always comprehended, at least were considered to be a necessary and useful part of the establishment. In England, as far as industry was concerned, they were regarded generally as irrelevant and outside the scope of trade, based as it was on harsh economic necessities. The Design and Industry Association did much to combat this unfortunate viewpoint, but it was still an uphill struggle.

Brocarts, brocatelles, lampas, Lyons silks all conjure up sumptuous visions. Delicate posies of flowers, as naturalistic and exquisite as any that decorated the fine porcelain of Dresden or Sèvres, the golden bees and stars of Napoleon, resplendent on their green or yellow background, the shepherds and shepherdesses of the Toiles de Jouy, as popular a hundred years later as the willow pattern in England, all this had been challenged by the stylised garlands of Art Deco and the wit and charm of the printed linens. It is sad that these things should be, by their nature, so perishable for they tell us much of the generations that produced them.

In the Report on the Exhibition issued by the Department of Overseas Trade, Sir Frank Warner gave a very full account of the textiles in the various pavilions and commented on many of them. Of the Lyons Pavilion he wrote that 'Some would have found in these silk weaving of Lyons the seeds of an over-exuberant fancy which has gone beyond the bounds of former canons of design. Others would have seen in them a faithful expression of the modern spirit. They were original in conception and modern in design and therefore, the Exhibition was their right place.' And again, 'A novel method of rendering many of the designs of the Lyons fabrics may perhaps

Furniture and curtains by Paul Follot in an English country house

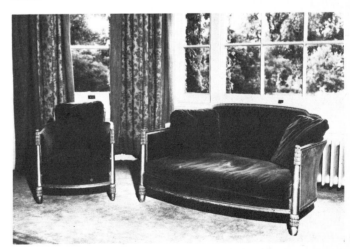

be best described by comparing it to the strokes apparently made at random of a large brush charged with colour or gold paint. Actually, the strokes are, of course, carefully and skilfully disposed.' He noted too, that some of the repeats were unusually large, even in some cases taking up the entire width of the fabric. There was, certainly, a boldness, an adventurous spirit, a willingness to experiment with untried ways combined with a knowledge of the power of texture and colour to enhance a decorative scheme, to evoke and sustain a mood which could be restful, dignified or gay as the occasion demanded. Most of the ensembliers used their own designs in the execution of their projects or supervised the work of specialist designers in their studios. Besides the Lyons factories, the firms employed in carrying them out included, among others, Bianchini Ferier, Pomone, Coraille Frères and Tassinari et Chatel. Bianchini Ferier achieved some remarkable results with printed velvets as well as printed linens and cottons. Paul Follot was particularly successful with brocaded stuffs, the all over designs giving a feeling of richness allied to cool and restful tones, whilst designs such as 'Les Biches' showed him equally capable of coping with hand blocked printed linen. There were two outstanding designers in his 'Atelier Pomone', Madame Schils and Mademoiselle Labaye, both of whom produced beautifully balanced and charming, imaginative effects. Maurice Dufrêne was an equally versatile textile designer, and cascading fountains, flowers and swags in multi-coloured and two toned brocades were typical of his work. One of these was chosen for the great curtain of the Opera House in Moscow. Dufrêne also could produce simpler designs of great distinction. There were, of course, a host of other textile designers, including Robert Bonfils, Benedictus and Montagnac. But no account of this branch of decorative art would be complete without reference to the work of the painter, Raoul Dufy, whose work in connection with Poiret's Atelier Martine, in a sense, pioneered the freshness of approach to the design of stuffs both for furnishings and fashion. Paul Vera was another artist who reflected the taste of his day, both in textiles and ceramics, while Mme Pagon's introduction of batik and her often brilliant abstract motifs captured the imagination of Parisians and approached the spirit of the more adventurous British designers, such as Marion Dorn or Phyllis Barron.

Poiret used figured materials for his dress designs with great effect, some of which were on exhibition in 1925, but, on the whole, the mode was for plain materials skilfully combined or of one colour such as figured satins or crêpes. Embroidery was used frequently for enrichment and, of course, the lamés for evening occasions with pure silk crêpe de chine a favourite for lingerie, usually in pastel shades or, more daringly, in black.

It is interesting to note the influence exerted by men and women who were primarily painters and illustrators on the development of Art Deco. I think that is is permissible to include Léon Bakst in this category as few would deny the revolutionary effect of his decors for the Ballets Russes. Then there were the Delaunays, particularly Sonia, with her brilliant use of masses of pure colour, and Raoul Dufy who has been mentioned already in this connection. One can also name Dunoyer de Segonzac, George Barbier and Van Dongen, all of whom made designs for textiles and carpets, in addition to men like Erté and Paul Iribe, who brought fashion drawing to an extremely high level. Van Dongen, rather surprisingly, even illustrated the fashion catalogues of the Galeries Lafayette.

Carpets provided another field for experimentation in design and colour. The large plane surfaces offered a tempting field for imaginative decoration, at a time when the rooms in the big apartment houses in Paris and the larger cities were almost universally floored with parquet. Rugs, usually oriental or not very good copies of Savonnerie or similar type, were placed thereon, usually avoiding the heavier pieces of furniture. In the bedroom one or two 'descentes de lit' were de rigueur. Art Deco ensembliers more often preferred to close carpet their rooms with an even tone as a background to their hand knotted rugs, the colourings carefully chosen to correspond with the general scheme. Furs were used on occasion.

Suë et Mare, Benedictus and others contributed modern designs for machine made 'moquettes' but most concentrated on the deep pile hand made woollen rugs. Some of these were of considerable size, such as those commissioned for large dining rooms, salons or music rooms. Sometimes, the floral motifs were cut obliquely in the Chinese manner to give an added accent to the design and to imply a feeling of depth. They formed an important element in practically all of the ensembles contrived for the Exposition and, as in painting, were usually characteristic of their creators. The Martines had, as with other media, used bold but harmonious forms and colours, while Paul Follot combined wavy, abstract shapes with stylised flowers, often with an incredible number of different shades which produced an almost painterly effect. Coudyser, Ruhlmann, Dufrêne, Benedictus all achieved success in this medium, and it is tragic that so few of these carpets have survived. The taste for simple but subtly aligned abstract designs barely had developed in 1925, and, when it did, it again was inspired by painters, Picasso, the Cubists and Mondrian in particular.

Tapestries were also featured in the Exposition. As in other media craftsmen during the 19th century had been concerned with trompe l'oeil effects, often achieved with extreme technical ability. The workers in the old established factories, such as the

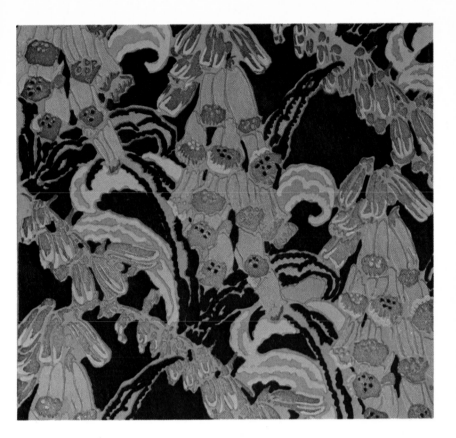

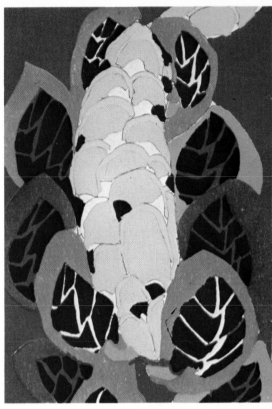

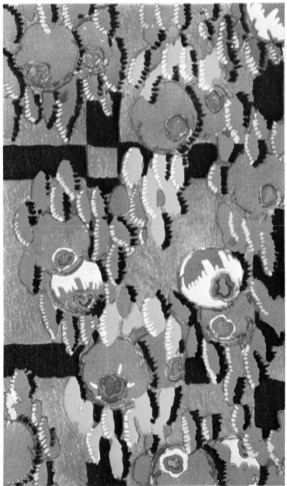

Textiles by Bianchini, Ferrier, Benedictus and Pomone

Hand blocked linen, Les Biches, *from Pomone*

Textile by Sonia Delaunay designed for a boutique on the Pont Alexandre III

Gobelins or Aubusson, were very highly trained, attending life classes for drawing and studying minutely everything appertaining to colour variation and juxtaposition. The sculptor Bourdelle had at this time charge of the life school at the Gobelins.

Significant changes were brought about by simplification in the approach to design and the costs of production and by the difficulty in obtaining permanent dyes. Apart from the important matter of texture, tapestries for wall hangings did not vary much from mural painting. Jaulmes had supplied the cartoons for some very impressive pieces, decorations typical of his manner and one in the best historical tradition specially commissioned to celebrate the entry into the war of the United States. The Gobelins also exhibited a series of tapestry panels by Jean Verber, illustrating favourite fairy tales, and Maurice Denis was another well known artist to contribute cartoons. Smaller notable pieces included those by Maurice Taquoy, Paul Vera and, again, by Jean Verber. A large tapestry panel occupied one of the walls of the dining room in Ruhlmann's Hôtel d'un Riche Collectionneur.

Several of the foreign exhibitors included tapestries in their pavilions, notably Poland, Czechoslovakia and Sweden. Not unnaturally, these tapestries exhibited marked national characteristics though already there were leanings towards an international style. It is difficult to say how much the indigenous decorative arts, in this as in any other medium, had been influenced by the French initiative.

The artists who created Art Nouveau were quick to recognise the tremendous potential of wrought iron and bronze as a decorative medium, not only for its uses in balconies, gates, railings and the like on the exterior of buildings but also for its manifold applications in schemes of interior decoration. It was particularly adapted to the sinuous lines and curves that were so much a feature of the style of men such as Horta, Guimard and Majorelle who created balustrades, grilles, door furniture and lighting appliances of often a rare distinction.

Iron was used increasingly for structural purposes, and it is interesting to find it replacing conventional pillars in halls and drawing rooms and culminating in spreading curvilinear branches for the support of the wider spans or domes of coloured glass.

The evolution of design from Art Nouveau to Art Deco is perhaps nowhere more marked than in the art of the smith. There were several notable practicians but this skill was unquestionably dominated, especially in 1925, by the master craftsman, Edgar Brandt and his workshop in Auteuil. Brandt came of an Alsatian family which had moved to Paris after the Franco-Prussian war. He served his apprenticeship at the technical college at Vierzon and went on to achieve a complete mastery of his chosen material. His work is remarkable for the combination of traditional skills

La Soie *by Marcel Reynard*

and the use made of the opportunities given by new technology. Autogenous welding, a process permitting the combination of different metals, brass, copper, bronze and iron, and the 'marteau pilon' or power hammer, with other technological advances, were used by him with complete understanding of both their potential qualities and their limitations. The use of these tools resulted, of course, in a far greater output and a lowering of costs. His decorative designs display a singular lightness and grace which was demonstrated amply by the doorways, screens and lamp standards in his section at the Exposition and by his work at the Ambassade. Where the metal was used, however, as support for heavy marble tops of tables and consoles, the characteristic forms showed appropriate strength. Brandt also designed the gates and grilles for the Porte d'Honneur but, for reasons of economy, the latter were not carried out in metal. Brandt also could achieve a monumental dignity, as in the war memorial at Douaumont and the tomb of the unknown soldier below the Arc de Triomphe.

Raymond Subes was another artist in this medium who showed individuality in design and craftsmanship, as were also Edouard Schenck, Richard Desvallières, André Ventre and others. Wrought iron was used frequently for lighting appliances, mirrors and other accessories; in combination with glass or marble, it could be extremely effective.

It would be unwise to limit an investigation into Art Deco to what actually was shown at the 1925 Exhibition, the details of which are recorded in the official reports and catalogues. It would appear to be of greater interest to attempt an analysis of the thinking that lay behind the designers' products.

Certainly an instinct for purity of form, a desire to reach out to the essence, an austerity in three dimensional design, whether in sculpture, pottery, glass or other media, was an important facet. There is a paradox here, in that this feeling ran parallel with a characteristic exuberance and an almost baroque richness of texture. Doubtless, sculptors like Lipchitz, Brancusi and Archipenko exercised a strong influence. Natural form and movement were reduced to essentials, sometimes with powerful understanding and subtlety, at others as a mere exercise in subtraction. Nor was this analysis and simplification confined to three dimensional objects, for it is evident in lettering, poster design, illustration and, indeed, in all the graphic arts. In spite of certain extravagances, it is also true of the stylisation of floral motifs, so typical of carpets, textiles, sculptural relief on stone, wood or metal, which can be contrasted with the botanical accuracy of, say, the decoration of a Meissen plate. At this point, it is extremely difficult to differentiate between Art Deco, which it is possible to consider as mainly Latin, and the forces of De Stijl, which equally could be ascribed to Nordic sources, although actually they overlap and interlock. Nor must it be forgotten that Le Corbusier, who was certainly one of the founding fathers of the modern movement, was a Frenchman, and his exhibit at the Expo in 1925 did not pass unnoticed.

There was another factor influencing the design of the 'twenties. These were the early days of our modern technological world. Aeroplanes, the motor car, wireless telegraphy, gramophone recording and loud speakers were all in their comparative infancy, hardly any of them had pre-dated the century. Even the humble free wheel bicycle, as a more rapid means of propulsion, was comparatively new. The dawn of this new world and the changes that it heralded were anticipated by the more perceptive, and there was an element of this excitement in the discovery of a new beauty in machines, the conception of speed, the new horizons opened up by the possibilities of rapid communications and travel, the recording of music, the moving picture, photographic reproduction. The list was endless. Fernand Léger was one of the first to express this feeling, although Wyndham Lewis's vorticists followed on. Technical expediency produced streamlining, the long low lines of automobiles, for instance, while the simple practical forms for diffusing light from electric fixtures were symptomatic not only of the discovery of the possibilities of aesthetic satisfaction in the appreciation of these new shapes, but also of a sense that comeliness was an automatic result of fitness for purpose. Natural forms result from natural function, and natural beauty is the consequence. It was therefore a relative truth to conclude that what was perfectly designed for its purpose would comprehend an intrinsic beauty. Added decoration of an object was superfluous, although where decoration was the primary purpose, this conceivably could be another matter.

Another factor that was only beginning to be significant in the 'twenties and that now has become of primary importance was the emergence of new materials. Concrete hardly can be described as a new material, the Romans used it consistently, but reinforced concrete was employed in novel ways. Steel tubing was used as a support for chairs and tables and thick plate glass for surfaces, while stainless steel, artificial silk, plywood of varying thicknesses, sometimes bent as in Alvar Aalto's classic designs that are still being manufactured today, were also available. There was little else. Plastics had yet to appear, if one excepts celluloid used principally for imitating ivory and of course in photography. It would be a complex task to enumerate all the man made materials in use today or to assess either their influence on design or, indeed, the impact of a changed way of life. Unlike a painter, the designer is bound by the function of the object to be designed. There

Panel by Edgar Brandt

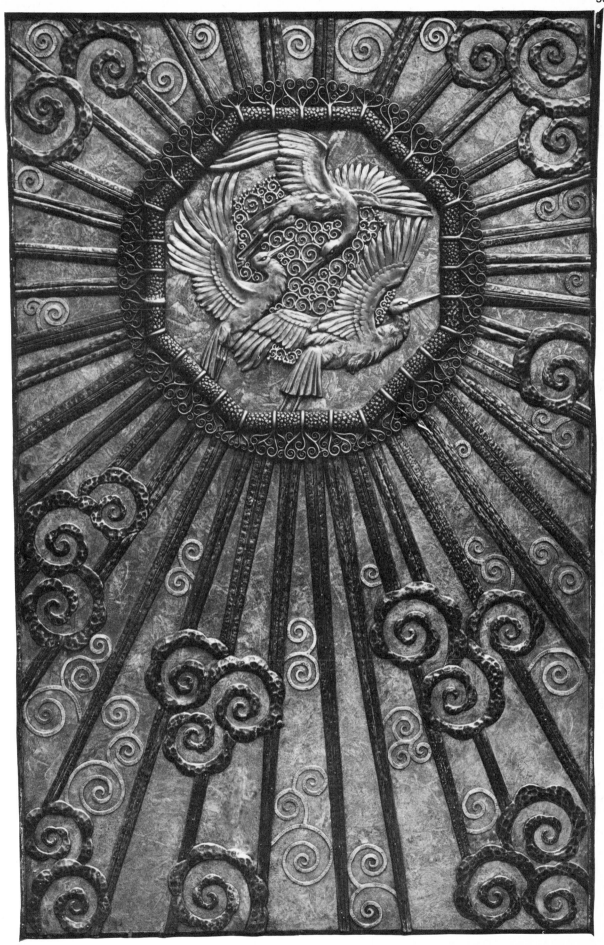

is no restriction on what may be put on the label of a can of soup, but the can itself needs to be airtight and of a shape suitable for packing and storing. A chair is for sitting on and must support the sitter adequately and in comfort, and its proper construction is of prime importance.

Contemporary fashion is also an important factor in this connection. Hoops and crinolines, for instance, dictated the proportions of chairs and sofas of earlier ages. These may be obvious considerations, but they still need to be borne in mind in assessing the quality and suitability of a product. While on the subject of chairs, it is well to remember that the craft of a chair maker is not identical with that of the cabinet maker, and, though the pieces may be made to match each other, their construction stems from a different tradition. Some of the most interesting pieces conceived by the Art Deco designers were the chairs in which the purity of grace and line and the practicality could be said to match the great achievements of the eighteenth century masters, either in France or England. And then, of course, a year or two after the Exposition came the revolutionary use of tubular steel, a development which, perhaps, caused the greatest shock to traditionalists. Thonet, the makers of bentwood chairs which were in universal use at the turn of the century and were used by Le Corbusier in the pavilion of L'Esprit Nouveau, mass produced this sensational tubular steel shaped frame with stretched tough canvas, the brain-child of Breuer, perfectly balanced and with no apparent support at the back. It took courage to realise that stability, lightness and comfort could be achieved in this way, even more to marry it to furniture made of more usual materials. Concert halls and restaurants were quick to understand the possibilities of stacking chairs of this type, and, indeed, they are commonplace today. It was the emergence of such new materials and the impetus they gave to mass production, in the face of the prevailing economic forces, that proved to be the true catalyst. The age of the designer-craftsman was fading while that of modern technological methods dawned. The benefits of this shift are emphasised by the aftermath of Art Deco as it was understood in 1925. Interiors based on the designs of René Herbst, Robert Mallet-Stevens, Charlotte Perriand, Signot, Le Corbusier and others bear witness to their aesthetic quality and integrity. The UAM (Union des Artistes Modernes) along with Gropius at the Bauhaus Dessau and the group known as De Stijl were to become the new leaders. After the Wall Street crash in 1929, the clientele was changing too. The new rich were not so rich, and the demand for exclusiveness in either fashion or furnishings, retreated before the need for greater production and a wider market. The essence of this change seems to have been totally apprehended by the new generation of designers. Many of their models are still being made and are still appropriate to the 1970s.

All of the essential characteristics of Art Deco, purity of line, simplification of form, subservence of superficial decoration, are equally evident in the products of the potters. Art Deco designers showed a preference for simple, sturdy shapes for their vases and bowls, while a characteristic elegance for coffee, chocolate and tea services, with restrained decoration of stylised figures and floral motifs, was also typical. As in anything else, the material used has a powerful influence on the final shape. Porcelain, for instance, indicates a more delicate approach than pottery and permits a more detailed painted decoration. The factories at Limoges and Sèvres produced top quality services. Robert Bonfils and Suzanne Lalique, a daughter of René Lalique, were notable designers in this period. The former worked for the national factory of Sèvres and the latter for the firm of Théodore Haviland at Limoges, as did Marcel Goupy and Jean Dufy, a brother of Raoul Dufy. Factories at Limoges and elsewhere were commissioned by the big stores to execute designs produced in their ateliers, notably by Dufrêne for La Maîtrise, by Follot and Germaine Labaye for Pomone and by Madame Chauchet-Guilleré and Claude Levy for Primavera.

As the painters had turned to African art as a reaction to a decadent western tradition, so the potters turned to the sophisticated perfection and simplicity of Chinese and Japanese sources. Interest in Eastern art already had begun in the time of Art Nouveau, and Delaherche is a name that comes to mind in this connection. The same influence was apparent in the work of Lenoble, Rumèbe, Methey and Decoeur which was displayed at the Exposition. Not that any of these artists were copyists, far from it. They were reaching out for that nobility of form which distinguishes great art. Decoration was usually restrained in the various techniques employed. It is interesting to note, also, that some famous artists in other fields, such as Vlaminck and Derain, turned their attention to pottery at this time. It is not difficult to trace the roots of much of our contemporary work in this medium to the master potters of this earlier generation.

Some artists who made designs for pottery also applied their skills to the creation of objects in glass and produced shapes with an affinity to those achieved in pottery and porcelain. But there the resemblance ends, for glass is a material with entirely different potentialities, and the Art Deco designers were at pains to exploit these possibilities to the full. Félix Masoul is quoted as saying that glass making is the art of transparency. With its peculiar character of brilliancy, it could be described equally as the art of colour and reflected light. These qualities were shown with remarkable originality in some of the stained glass that was exhibited, for example in the church of the Village Française by Barillet.

Blown glass, vases, bottles and table glass among

others were frequently decorated with contemporary designs in coloured enamels, and J. Luce, Marinot, Dufrêne, Chevalier and Goupy all made use of this technique. Since the time of Gallé and his contemporaries, artists experimented with every possible method of production, blown glass, cut, moulded, opaque, clear, iridescent, light and opalescent or solid and sculptural, and, of course, with the unique products of the 'pâte de verre' process. Maurice Marinot was undoubtedly one of the most outstanding of the Art Deco craftsmen working with glass, and he was followed closely by Dammouse, Decorchement and the Daum brothers of Nancy. The name that will be associated forever with this period is, of course, that of René Lalique. Lalique was an exceptionally gifted designer and craftsman and by producing his models in large numbers made them available to people of moderate means both in France and abroad. He also demonstrated that glass was a suitable material for a wide variety of domestic uses. Besides table glass, statuettes, clock cases, table lamps, pendants and standard lamps in combination with metal, illuminated car mascots and a brilliant series of scent bottles for the firm of Coty, he produced fountains, wall panels and candelabra for the Exposition. The quality of this vast production cannot be said to have suffered. Lalique had a very personal style and great skill in contriving that the passage of light should accentuate the moulded form.

Mention must most certainly be made of Jean Dunand, probably the most outstanding craftsman of the period, whose work as much as any embodies the spirit of Art Deco. Dunand brought the art of lacquer, and of eggshell lacquer, to absolute perfection. These processes are lengthy, necessitating extreme skill if a high quality of finish is to be obtained, and his pieces were, therefore, unique and certainly elitist and costly. His designs for the smoking room at the Ambassade greatly enhanced his already high reputation. His vases and other objects in dinanderie were executed with the same conscientious skill. They had a distinctive nobility of form and outline, and the combination of metals used produced patterns of rare beauty. Another artist in this medium was Claudius Linnoissier, who exhibited some very fine work of this type.

The eggshell lacquer technique was used also by goldsmiths and jewellers, notably by Paul Brandt, for small objects such as cigarette and vanity cases, belt buckles among others. Jewellery, not unnaturally, followed the prevailing modes. Short hair indicated long earrings rather than tiaras, while large chunky bracelets and necklets for bare arms and plunging necklines were also fashionable. Raymond Templier, Gerard Sandoz, Jean Fouquet are names that come to mind and some excellent work was done in this medium, although it is doubtful if it excelled that of such Art Nouveau designers as René Lalique. Squares, ob-

longs, segments of circles were the basis of most designs.

This was an important period too for the art of the silversmith and the pieces executed at this time are much sought after by collectors. Jean Puiforcat, Gerard Sandoz, Suë et Mare, the firm of Christofle, who employed various designers including Paul Follot all made distinguished contributions, and, of course, there were many others. In a brief survey such as this, it is impossible to produce a comprehensive account of all that was memorable.

The artistic revival obviously affected everything concerned with typography and illustration, from book production to magazines and posters. Indeed, clear and arresting forms of lettering were developed for every medium. The frequently brilliant drawings in the glossy magazines and their advertisements for the world of fashion have left an indelible impression. The posters of the period were equally remarkable. Those by Cappiello, in particular, were both colourful and forceful and carried their message with an extreme economy of means. The work of the Draeger brothers, Jean d'Ylen and Jean Dupas should also be noted.

But this 'art of publicity' should not obscure the achievements of the book illustrators. Reference is made elsewhere to the British contribution. In the book section at the Exposition, the work of such men as Forain, Naudin, Steinlen, Laboureur and Guérin, as

La Vierge écrasant le serpent, *vitrail by Barillet in the village church*

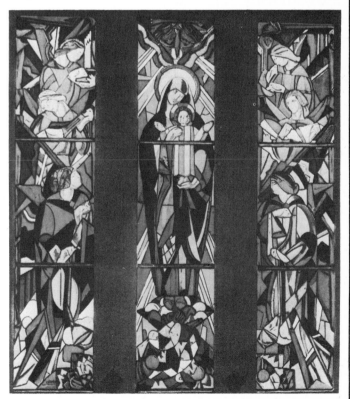

well as that of Dunoyer de Segonzac and George Barbier were evidence of the high level attained. An interesting phenomenon was the revival of interest in the woodcut, based on 16th century techniques, and numerous fine books were embellished by this method.

Returning to the 'mode', it is possible to visualise the actual dresses and accessories worn by women in 1925 and thereabouts by consulting the contemporary fashion plates and the indispensable publications of Condé Nast. There was certainly a very important section of the exhibition devoted to the art of the couturier, which over the years, had been elevated to a point, at least in public esteem, to that of any of the decorative arts. A great many causes contributed to this, some psychological, others commercial, while still more influences fed both the individual genius of designers and the exceptional skill of the artists employed to publicise them.

Paris was the undisputed leader in the world of women's fashion. One has only to glance over the books on costume by Octave Uzanne to understand how long this, in fact, had been the case. The glorification of the 'eternal feminine', the perennial charm of the 'Parisienne', her inimitable style and chic were legendary. It is a curious fact, however, that one of the first to create a 'grande maison de couture' and to develop it into a successful commercial enterprise was a somewhat eccentric Englishman, Worth, who enjoyed the distinguished patronage of the Empress Eugénie. In 1932, Poiret published an entertaining book of memoirs entitled *Revenez-y*, which has a fascinating chapter on Worth and his successors, Jacques Doucet, for whom Poiret had worked as a young man, Paquin, the originator of the 'costume tailleur', Patou, Cheruit, and Chanel. It was, however, Poiret, himself, who gave the impetus to what was a radical change in women's fashions, the simplification of the line, the end of 'stays', tight lacing and high boned collars. He is credited with the abolition of the corset and the invention of the bra, although the war may have brought that about. I (M.T.) have poignant memories of the Parisian women at that time, most of them swathed in the black crêpe, which was the universal and outward sign of mourning.

By the early 'twenties, haute couture showed vigorous signs of post war recovery and these were given full expression in the Pavillon d'Elégance. Fashion was an extremely valuable export commodity and gave employment to innumerable people involved in manufacturing industries. This was still a world where personal pageantry and individualism counted for a great deal and enormous importance was attached to the external expression of a civilised taste. The extraordinary feat of wearing individual clothes and yet following the dictates of the leading designers was somehow accomplished. The wealthy bought the original models at vast expense, the less well off patronised intelligent dressmakers who took copious notes when viewing the

'collections'. Furs were extremely popular in 1925. Most of them would be unobtainable now, as would the osprey feathers that adorned the fashionable turbans for evening wear. This is hardly to be regretted with our pressing need for conservation of wild species, but during the 1920s the supply appeared to be inexhaustible.

The furriers, Revillon et Cie, Heim, Fourrures Max, A la Reine d'Angleterre, among others, exhibited the most sumptuous garments made entirely or trimmed with furs, the last word in winter luxury. White and silver fox, ermine and seal, mink, leopard skin, beaver, musquash, and, of course, moleskin and grey squirrel. Revillon showed a particularly luxurious coat trimmed with 'lièvre mauve'.

Most, if not all, of the grandes maisons were represented at the Exposition. The general characteristics of their designs were slimness and elegance, long lines accentuated by the virtual disappearance of the waist line and the low cut 'V' shaped back for evening. Representative accessories included transparent scarves and veils of silk georgette, embroideries in gold and silver thread or tiny beads and long tunics

Le Pavillon de l'Elégance

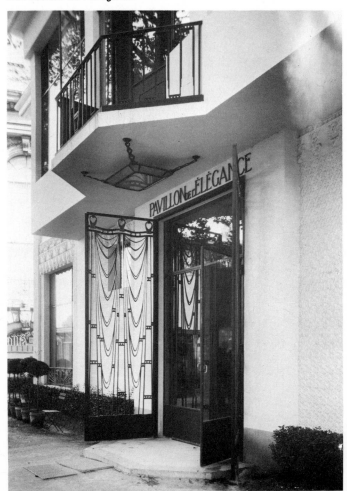

over skirts with hem lines some eight inches from the ground. The 'svelte' outlines were exaggerated by the highly competent fashion artists to give a fantastically stream-lined effect. The normal figure is from six to seven times the height of the head whereas in the drawings the proportions rose from eight to nine or more. There was indeed a precedent, for Gothic sculptors used the same device for their figures of saints on the façades of churches. Alas, the photographer has eased the draughtsman out of this particular job, but he is less able to 'flatter la marchandise'.

Hats, of course, were still de rigueur, and these tended to be small and close fitting, although there was an infinite variety. Short hair or at least a modest bun at the nape of the neck was fashionable. The horrors of the 'perm' and plastic curlers had yet to come. Hair styling before and during the '20s was achieved by making waves or 'ondulations' with curling tongs, a process which involved considerable skill.

It is interesting to note that Lady Duff Gordon, a sister of Elinor Glyn, was director of Lucille, one of the leading fashion houses, and it was she who first employed the young Englishman, Captain Molyneux.

He was wounded in the war but survived to gain a leading place in the world of fashion. Madame Vionnet was a brilliant dress designer as was Sonia Delaunay with her wonderful sense of colour and feeling for theatrical costume. Georges Lepape, Paul Iribe, George Barbier, Raoul Dufy, Domergue and Van Dongen also interpreted the scene brilliantly.

Owing, perhaps, to the availability of Caen stone for building, the average Parisian was more familiar with the art of the stonemason and sculptor than his London counterpart. Most houses built both before and during the 1920s were embellished with carved decoration and most squares with statues or fountains. It would be unprofitable to attempt to differentiate between carvings in relief and free standing sculptures as both may form part of a decorative scheme, or, at least, relate to the adjacent architecture. There was much of interest at the Exposition but, taken as a whole, the sculpture was not entirely representative of what was a particularly fruitful period. Very typical of Art Deco was the large group by Janniot, already referred to, which stood in front of the Pavillon de la Ville de Paris.

Evening dress by Poiret, fabric by Raoul Dufy

Dress by Vionnet

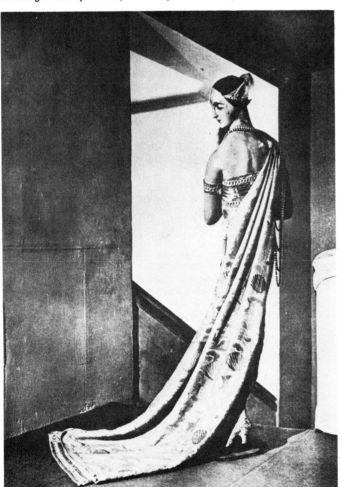

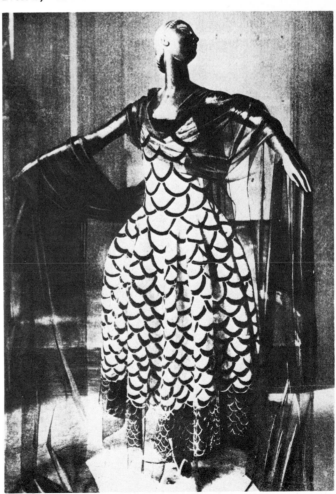

The reliefs by Bouraine, which adorned its walls, were similarly characteristic.

The sculpture of men like Bourdelle, Maillol or Lipchitz belonged, of course, in a different category. The last had a fine statue in front of Le Corbusier's Pavillon de l'Esprit Nouveau, and the first of these exhibited a figure for a memorial to the fall of Hartmannswillerkopf. It was Bourdelle's magnificent reliefs made for the decoration of the Théâtre des Champs-Elysées and executed before the war which were the inspiration for much of the sculpture that followed. His work gave a feeling of tremendous power, and he certainly enjoyed the interpretation of ancient Greek themes in his own contemporary idiom. 'This is what I do to please myself' he said once, pointing to his 'Dying Centaur' in the great studios that are now the Musée Bourdelle. Mention should also be made of the 'animaliers', Pompon and Jouve, who, with their impressive understanding of mass and movement, exerted a wide ranging influence.

In France, small sculptures in bronze, marble, terra cotta or imitations of these materials had always been a popular part of the interior decor. In the 'twenties, some fine examples of sculpture in pottery were pro-

duced, some with a cream crackle glaze or shiny black or again with two or more colours. In the best examples, the accent, once more, is on the main elements of form and movement, as in Jouve's black panther.

The 'twenties, like any other age, was full of anomalies. If it produced highly skilled craftsmen, it also saw the emergence of Dadaism and Surrealism, difficult, perhaps, to marry with 'Fitness for Purpose', but all concerned with the revolt from traditional controls that could stifle the precious and fragile creative faculty.

It is perhaps apposite to quote here the first paragraph of Henry Wilson's chapter on metalwork in the British Report. 'The Paris Exhibition, its variety, its multitudinousness, its unending vitality, its instant ever-changing appeal was a thing that no report can render. It had to be lived to be realised, visited many times before being fully accepted. Yet when you had taken it to your heart you became aware what a fund of interest, what a source of unending stimulus, what a mine of marvels had grown up in the heart of Paris. No report can give any idea of its charm. It was radi-

Callot Soeurs display

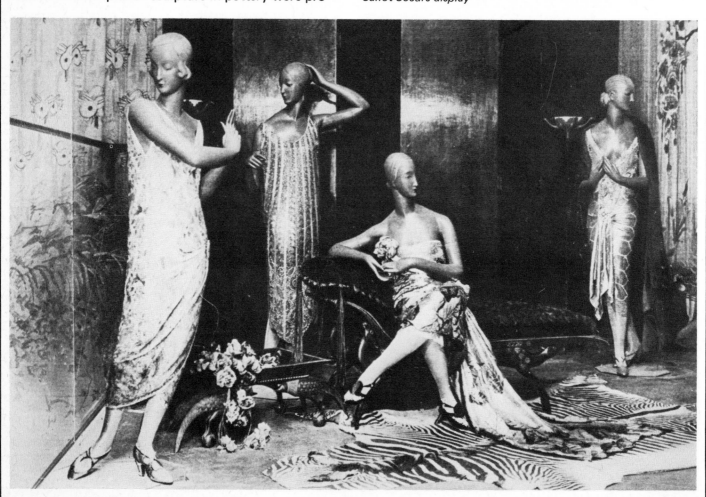

ant promise, to which was added much brilliant performance. It was partly realised prophecy. Everything was in bud: the germination of new ideas was visible everywhere. A seed is a small thing as performance, yet in time it may produce a forest of oaks. What intrigues one at present is what the forest of oaks will be like which will assuredly spring from this decorative acorn. While the full effect of what has been done can only be realised in the future, much has already been achieved. Numbers of French artists have had the time of their lives, with fair pay and unending opportunity of realising dreams, on the flat or in the round, all urged by friendly rivalry to do their best and hardest'. These words were spoken with the spirit of William Morris. Alas, the great forest of oaks was to be brutally decimated in the years that followed, but, equally, there is no shadow of doubt that the Art Deco artists achieved their objective and changed the entire character of the decorative arts. They also left behind them works that take their place worthily in the great heritage of European and western art.

The rough and the smooth: (below) Monument by Bourdelle; (left) Jeune fille à la cruche *by Joseph Bernard, shown in le Pavillon d'un Riche Collectionneur*

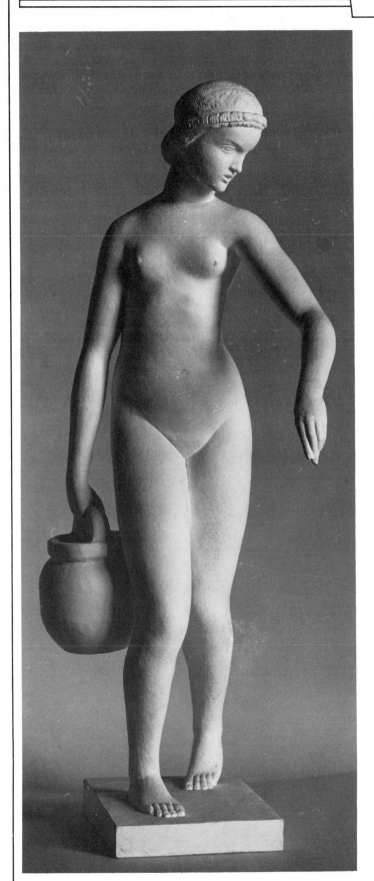

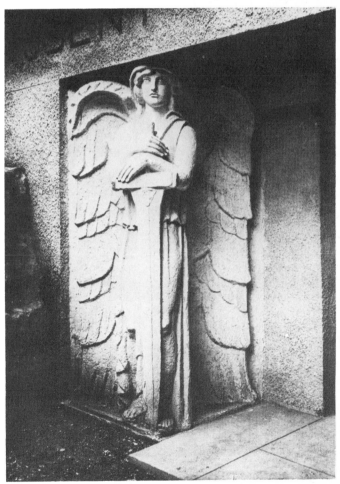

LE PAVILLON
DE L'ESPRIT NOUVEAU

We have left the description of this building to the last because it was this that bore the seed of the movement in the arts that was very quickly to supersede and universalise the conflux of modern styles displayed in the exhibition. Not only was the style of each foreign country different, but also French artists, even those of the Academy, expressed themselves in varying modes despite their common purpose. This was the international style that spread

over the world in the fifty years that followed.

Although the architect of this pavilion, Le Corbusier was not the originator of the movement, it had been his own earlier buildings together with his writing that lit the fire kindled before World War I by Walter Gropius and Mies van der Rohe, to mention

Le Pavillon de l'Esprit Nouveau, front with sculpture by Lipchitz and hanging garden

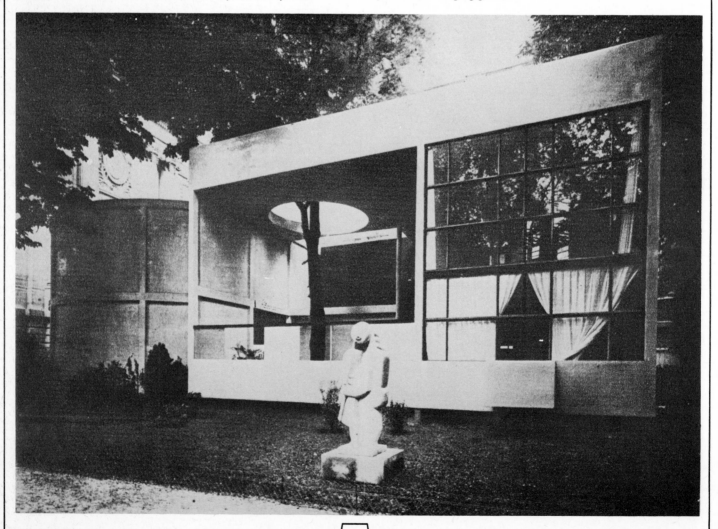

only two. Le Corbusier's ideas had first been promulgated in *Vers une Architecture* in 1919. By 1925, he had built the villa at Maucresson, a house in Paris for Ozenfant and the pair of houses at Boulogne sur Mer, one of which was for the sculptor Jacques Lipchitz. He also had failed to secure the contract for the League of Nations Headquarters in Geneva after submitting a design in competition that had awakened enthusiasm all over Europe.

In his own words, the pavilion was an epic achievement undertaken with no money and no land and in the face of bitter opposition to the design from the Director of the Exhibition. It was only at the last minute before the opening, by direct intervention from the Minister of Fine Arts, that the hoarding, 6 metres in height, erected by the authorities to conceal the building, was removed.

The purpose of the building underlying the architect's conception was to deny the necessity for decorative art and to demonstrate that it was equipment that a dwelling needed, not furnishings, apart from a few Thonet bentwood chairs. He also exploited successfully the new liberties and radical solutions provided by steel and concrete construction and, although he does not say so, the building was suffused by the architect's delicate poetic sensibility, akin to that of Juan Gris, one of whose paintings was among the few hung on the walls.

The pavilion was in two parts. One was an individual dwelling or 'cellule' designed to be part of a larger agglomeration, differing from the typical block of flats in that the unit occupied two floors one of which in parts was penetrated by the other to give a main salon of double height and a hanging garden. The effect was most exciting particularly by contrast with, for example, some of the rather overstuffed rooms in the Ambassade Française, compared to which the clinical appearance of the interior designed

Salon in le Pavillon de l'Esprit Nouveau

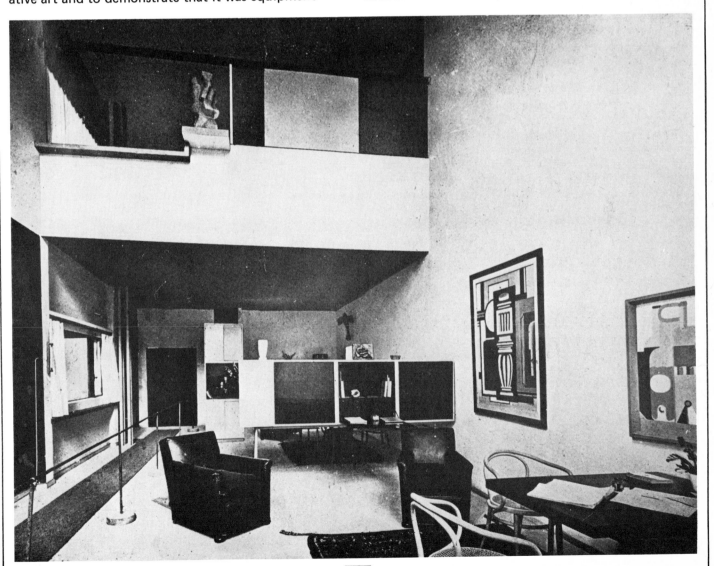

by Le Corbusier was like the cold plunge after a Turkish bath.

The other half consisted of a hall arranged for the display of studies in town planning and was dominated by the 'Plan Voisin de Paris', which embraced most of the second, third, ninth and tenth Arrondissements north of the Rue de Rivoli. The basic conception of this scheme was to raze the existing buildings except for a few very special monuments, clear the ground and erect a series of regularly disposed tall buildings, to house three million inhabitants as well as offices, restaurants, theatres and facilities for all the multi-farious activities of a capital city. The project was to be faced with glass, gleaming like crystal, while on the ground a landscaped park traversed only by a through highway running on columns from south east to north west was foreseen. This was a romantic dream that has only very partially and inadequately been realised elsewhere and probably never will be undertaken in Paris.

This domestic unit provided the stylistic motifs that later became a world wide set of clichés in domestic design: the flow of space horizontally and vertically, asymmetry and the use of elementary elements, mainly metal, for staircases and railings, cantilvered balconies in concrete. The main elevation faced the street across a lawn and consisted of two elements, the balcony of the hanging garden and the end elevation of the living room, both embracing two storeys. The living room window occupied the whole of the end wall of the gallery, and the windows to the upstairs and downstairs rooms faced the garden. The roof of the court had a circular hole through which grew a large plane tree that had flourished on the site before the pavilion was erected and the whole structure was of smooth rein-forced concrete. A statue by Lipchitz graced the front lawn. The building attracted great interest and some disapproval. At the opening ceremony, the Minister, M. de Monzie, said 'As a representative of the Government I must affirm our sympathy for such efforts: a Government must not remain in ignorance of such researches as we see here.'

GREAT BRITAIN
PART ONE

While France may have seemed to enter into the Exhibition in a spirit of confidence in re-establishing her rightful place in the leadership of the arts, no such spirit of conviction seems to have motivated the British entry. In the first place, the regulations covering the Exhibition seem to have been a matter of concern to those organising the British contribution and, in particular, the question of the meaning to be attached to 'modern inspiration and real originality' gave rise to some speculation and disquiet, coupled with a general feeling that design was not being given enough attention in the industrial arts in Britain.

The organising Committee, among whom were Sir Hubert Llewellyn-Smith, Sir Reginald Blomfield, Sir Eric MacLagan and Sir Frank Warner, were anxious to be reassured by the French authorities that exhibits would 'not only be considered if entirely novel in design and although mere copies and reproductions must be rigorously excluded, the term originality should be interpreted in a liberal sense.' This interpretation was accepted by the French authorities and as will be seen, led to a curious ambivalence combined with a certain half-heartedness in the British Section.

The organisation of the British Section was under the direction of the Department of Overseas Trade and followed the lines of the British Empire Exhibition held at Wembley the previous year.

There had been an exhibition of British arts and crafts opened in Paris in 1914 which showed the work of Mackintosh, Voysey and Baillie-Scott under the leadership of Walter Crane and Henry Wilson, who also contributed to the decoration and general direction of the British Section of the 1925 Exhibition. The 1914 Exhibition was closed after the outbreak of World War I and remained in storage until it was over. It would seem that the ideas that it expressed may have survived to 1925 although as we have said, the ideas of the new era proved a revelation and inspiration to Henry Wilson.

The success of Wembley failed, however, to ensure that similar success in Paris necessarily would follow, particularly without Sir Lawrence Weaver's organising genius and flair for exhibitions.

An Advisory Council was appointed under the presidency of Prince Arthur of Connaught and besides a number of those mentioned elsewhere in this book who became exhibitors it also included Sir Reginald Blomfield, then engaged in designing the new buildings in Regent Street and Piccadilly Circus to replace those of John Nash and J.A. Gotch, who was president of the RIBA; Ambrose Heal, head of the well known firm of furnishers; E. McKnight Kauffer, whose posters for the London Underground were the most original yet seen by the British public and set a standard of design in poster art; the charming and talented Grace Lovat-Fraser, widow of Claud Lovat-Fraser, who for a tragically few brief years had overshadowed everyone in the arts of theatrical design; Nigel Playfair, whose production of *The Beggar's Opera* gave Lovat-Fraser so much scope; and Professor Albert Richardson, whose swan song after World War II, Bracken House in Watling Street, is almost the sole representative of Art Deco among the new buildings erected in the 'fifties. With such diverse talents as these it is odd that the tone of the British section generally turned out in some respects to be rather flat.

The British Commissioner was Colonel (later Sir) Henry Cole, who had been concerned with the Delhi Durbar of 1911 as well as with the British Government Pavilion at Wembley, where the Art Director, Major A.A. Longden had been in charge of the Palace of Art. Colonel Cole was an imposing figure with a genial manner and a kind heart, late of the second Gurkhas and formerly Deputy Commissioner for Assam. Longden had an ebullient personality, was enthusiastic, with a sense of humour and had been trained as an artist. After distinguished service in World War I, however, he developed his flair for exhibition work, and painting became his *violon d'Ingres*. Major Keatinge, subsequently Curator of the Imperial War Museum, was Director. Several other ex-British officers living in Paris had been recruited locally to assist in the organisation, as were the authors.

The design for the British Pavilion was awarded to Easton and Robertson in a limited competition assessed by H.S. Goodhart-Rendel. It is to the credit of the architects that their design was not 'mere copy or reproduction', and, although their source of inspiration is not apparent, the result was gay, light and unconventional by comparison with the heavy concrete

monumentality of the Wembley buildings or the British Pavilion at the Paris Exhibition in 1900, the latter a reproduction by Edwin Lutyens of a seventeenth century manor house, built in steel and concrete. The 1925 Pavilion was aptly described by H. de C. Hastings in the *Architectural Review* as 'saucy'. Hastings also pointed out that the best qualities of the design were not seen as one approached its main entrance from the Porte d'Honneur, but rather from the other side of the Seine, where the width of the building in its axial relation to the Restaurant Britannique, below at the level of the Porte des Champs-Elysées and below that to the péniche at anchor on the quay-side could be appreciated.

Entering under a fanciful parabolic arch into a vestibule flanked with Mycenaean ceramic columns one was confronted with a perspective, seemingly of nave and aisle, of which the focal point was a Pietà by Reid Dick, strongly reminiscent of that by Michelangelo in St. Peter's, Rome. This was the Kitchener Memorial, now in St. Paul's Cathedral, and, although imposing, it surely was neither industrial nor decorative. Perhaps it was deemed admissible under the rubric 'Class 1 —

Architecture (2) Public Funeral Monuments', but it was hardly 'modern' in the sense intended. In front was a kneeling figure, and above a wagon ceiling finished in a spandrel on which was mounted a faience roundel with a Madonna and Child in relief, obviously inspired by della Robbia. The decoration of the ceiling and walls was designed by Henry Wilson, President of the Art Workers' Guild, a metalworker and architect, who contributed the lively and appreciative chapter on metalwork to the report already referred to, as well as displaying some of his own work. With his typical modesty, he did not mention his own work in this report, nor that of any other British metalworker in the Exhibition. Other exhibits prominently displayed in the central hall included an altar frontal and hangings, crucifix and chalice and stained glass by Anning-Bell. It is hard to understand why such emphasis should have been given to the ecclesiastical arts, particularly as the exhibits chosen were not on the whole very original. The most probable reason is

The main entrance and south front of the British Pavilion, overlooking the Seine, with view of entrance and main gallery (right)

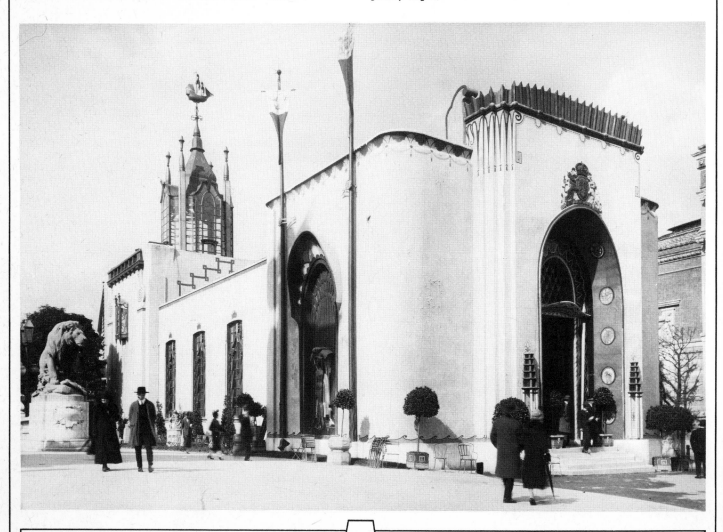

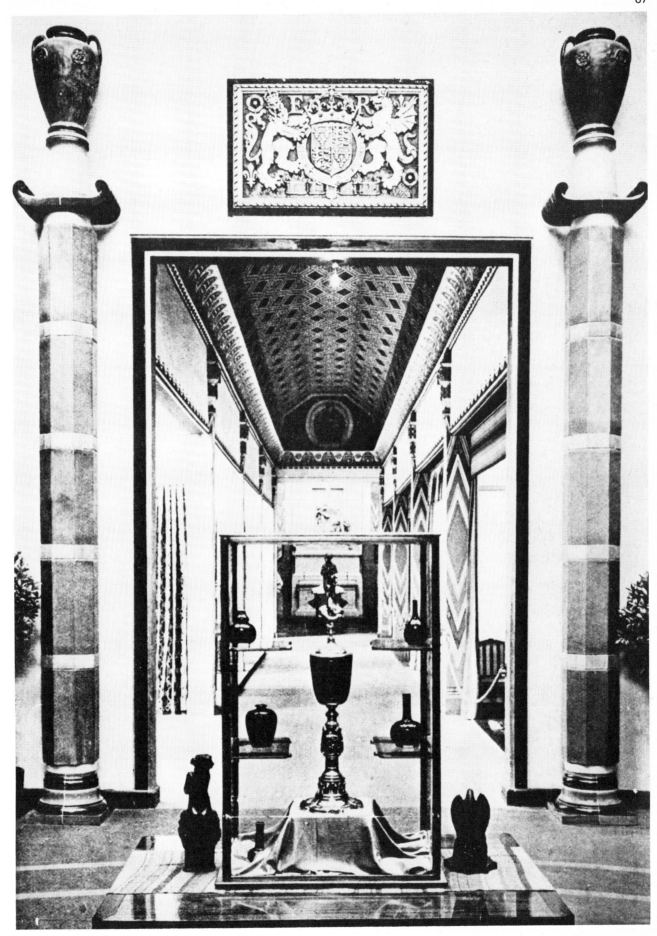

that they were thought to represent the most significant art and craft work of the time, and, although this may well have been true, one cannot avoid the dispiriting conclusion that the arts, particularly the industrial arts, were in a pretty bad way in Britain at this time. In the first place, the position of the designer in industry was not established except in a very few firms, and these tended on the whole to be conservative in outlook. The attitude that what had done well in the past ought to be good enough for the present and future was all too prevalent. Those few artists and craftsmen eager to preserve high standards tended to adopt an aloof and superior attitude to industry, which, in turn, regarded them as impractical cranks. The buyers for the large retail houses dictated their tastes to the manufacturers, and these were based on the opinion that they knew what sold. Art education was directed, particularly in the crafts, by those rooted in the traditions of the past.

Since those days, there has been much reappraisal and discussion of the place of the artist in industry. I think that the 1925 Expo was probably the first event that shook the manufacturers and public into an awareness of the need for better design and presentation, rooted in sound principles and unbiased by preconceptions. Certainly, the next British contribution to an international exhibition, that in Paris of 1937, showed a more comprehensive and enterprising outlook, which continued in post war exhibitions, such as 'Britain Can Make It' in 1946, the Festival of Britain and others since.

Although the impression of the British Pavilion of Honour was predominantly ecclesiastical, British pomp and circumstance came into their own in the inclusion at the opening ceremony of the band of the Cameron Highlanders, who marched and counter-marched up and down the magnificent staircase of the Grand Palais. This event made a terrific impact on the Parisians, who were also impressed by the Commissionaires in attendance at the Pavilion, ex-guardsmen, all over six feet in height and clad in frock coats with scarlet facings, brass buttons and cockaded top hats.

It would, however, be unfair to dismiss the display in the British Pavilion as outdated, socially irrelevant and meretricious without mentioning some of the work of interest and of quality that was shown. Although 'presentation pieces' in gold and silver, frequently inlaid in enamel and generally over-ornamented, were predominant, the craftsmanship in metalwork showed very high technical skill. Omar Ramsden and Henry Wilson amongst others showed outstandingly beautiful work, while in sculpture, a carved panel in low relief entitled 'The Mourners' by Gilbert Ledward in the ecclesiastic section had the same integrity and sense of beauty which distinguished his work until his death. There are two notable examples of Ledward's achievement in Chelsea, the fountain in Sloane Square and the figure of

'Awakening' on Cheyne Walk, near the Old Church, both female figures cast in bronze which, to my (F.S.) mind, in their classic but individual perfection bear comparison with Despiau or Maillol.

Four alcoves housed ensembles of furniture, soft furniture and domestic decorative objects, all 'arranged' by Mrs (now Lady) Maufe. The room designated as a living room suitable for a town house contained furniture from seven different manufacturers in a space of about 150 square feet, so it would seem that the services of an 'ensemblier' were needed to produce the unity of impact that the French achieved in the Ambassade, the Pavillon d'un Riche Collectionneur and the department stores. The pieces were arranged about a desk designed by (later Sir) Edward Maufe, overlaid with silver lead, that has been illustrated in several recent publications.

The Nursery contained furniture from Gordon Russell's workshops of Broadway, Worcestershire and curtains from the Barclay Workshops for Blind Women. This room showed a simplicity and single minded approach that the firm have always had, and it is good to know that Sir Gordon Russell, the first director, and his workshops are still very much alive and flourishing. Both they and Heal's contributed to most of the furniture exhibits and followed the inspiration of Barnsley, Voysey, Mackintosh and other forerunners of the late nineteenth and early twentieth centuries, Heal & Co. having established a name for good workmanship and selective taste for the best part of a century. Neither of these firms would have wished to display the opulent virtuosity of Ruhlmann, Follot or for that matter of Sheraton or Chippendale, but in their way they carried on the ideals of Morris.

The town bedroom exemplified the puritan element of the British character. The two single beds were placed on opposite sides of the room, with a glass bowl and pitcher on a wash hand stand on one side balanced by madam's dressing table and a hanging cupboard in the middle. Four symmetrically disposed lamps seemed to preclude reading conveniently in bed. Comparison with 'La Chambre de Madame', previously mentioned, shows the difference between the French and English temperaments.

The opinion has been expressed previously that William Morris's greatest achievement as an artist was in typography and book-binding as seen in the productions of the Kelmscott Press. If this is so, it certainly could be said to have borne fruit in the exhibits in the small rooms devoted to these crafts. Although none of the productions of the Kelmscott Press was paramount, its influence was seen in the volumes from the Shakespeare Head Press, St. John Hornby, Noel Rooke and the Golden Cockerell Press. It is a great loss that such books are no longer economically viable, for although expensive 'coffee table' books, which show enormous strides in colour photography, continue to be sold at high prices, the buying public is

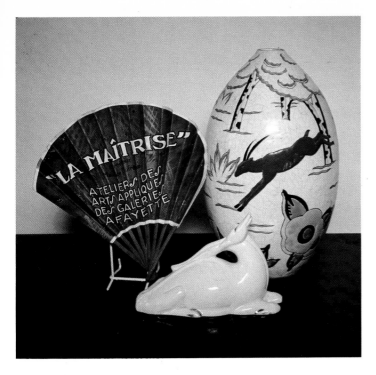

Pot from La Maîtrise, fan from La Maîtrise, deer from Primavera

Three pots by Staite Murray

Egg shell glazed pot by Raoul Lachenal

Coffee service from Pomone

Jewellery from Cartier

very limited for fine type-setting, good paper, hand carved wood block illustrations and tooled leather bindings.

The study of book production and illustration during this period and the years preceding the outbreak of World War I would be a fascinating but extremely lengthy task. One only can allude to a few salient points in this brief survey. Curiously enough, this was a field in which the British producers showed far less resistance to fresh ideas than in many others. This may have been due partly to technological advances in methods of printing and processing which were fast superseding the older ways. In any case, the material that came from the British presses could hold its own with anything produced elsewhere, and, although what was exhibited in 1925 was not entirely representative, it was still distinguished enough to demonstrate this achievement. Eric Gill's great contribution to typography, the quality of paper and binding, the fidelity of colour reproduction, the skilled integration of black and white illustration on the printed page, all this had reached a high standard. Notable illustrators included Arthur Rackham, Edmond Dulac, Lewis Baumer, Frank Reynolds, E.H. Shepherd, J.J. Thompson and Paul Nash, these being only a few of the names that could be quoted in addition to the great comics, Heath Robinson, Bateman, George Belcher, Fougasse and the rest.

There was one field, however, in which the British had an unquestioned leadership, and that was the budding art of radio. It is hard in these days to think back to the time when the 'wireless' or T.S.F. (the mysterious letters which stood for 'Télégraphie sans Fil') was an exciting novelty. After all, wireless sets had been in production for barely five years, and the amplification of sound and the relaying of music or speeches was

Silver chafing dish by Henry Wilson

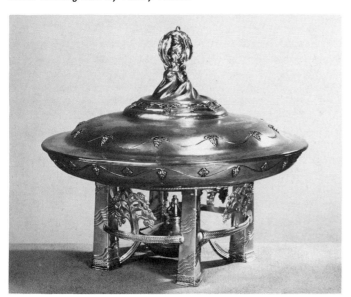

still a comparatively new phenomenon with its potential for mass communication just beginning to be realised.

The firm of Alfred Graham and Co., of London, installed a 'Public Address System' at the Exposition, the first of its kind to be heard in France, although a similar installation had been used the previous year at the British Empire Exhibition at Wembley, used notably for relaying a speech by King George V. There was a 'Pavillon Graham' on the Quai d'Orsay from which concerts were relayed and listened to by literally thousands of visitors, enjoying what was then a novel experience, an augury of developments to come.

Finally there were the restaurant and péniche. The restaurant was well planned and designed by the architects and catered for an Anglo-French clientele who expected and received the best of France and Britain under the direction of M. Martinez of the Carlton in Paris and the Casino in Nice. The péniche was moored at the lower quay level, beneath a painted roof executed gaily in Chinese lacquer orange, red and emerald green by Cynthia Kent and Barbara Game and served as a night club and the setting for many spontaneous light-hearted parties.

Rummaging among old press cuttings and articles in Fulbourn Manor, Cambridge (M.T.'s home), the authors discovered a rather tattered copy of the menu of the restaurant bearing a patterned cock and lion with Walter Crane's monogram. The title was:

EXPOSITION
INTERNATIONAL
DES ARTS DECORATIFS
PARIS

PAVILLON BRITANNIQUE

RESTAURANTS ANGLAIS

Avril—Octobre 1925

Walter Crane, however, died on 14 March 1915, and close inspection revealed that this inscription was pasted over the following:

MUSEE DES ARTS DECORATIFS
PALAIS DU LOUVRE
EXPOSITION DECORATIF
ANGLAIS
AVRIL—OCTOBRE 1914

The latter must have been cut out and pasted onto the catalogue of the 1914 exhibition which has already been mentioned. It is illustrated here, on page 8, in its own right as a work of art.

GREAT BRITAIN
PART TWO

Part two deals with the British exhibits in the Grand Palais and will show the national output over a wider field of production, the technical skill in manufacture and quality of material, even if the final results were often lacking in imagination.

The Ceramics Section in the Grand Palais exhibited the work of all the leading British potteries, the majority of whom were from the Five Towns in Staffordshire — actually there were seven of almost equal importance, and it was always a matter of debate which were the five — and of course from Worcester and others. The export trade flourished, particularly that to America, as, on the whole, the quality of the material and manufacture was first class. The great British firms of Wedgwood, Doulton and others made some important contributions as did Carter, Stabler and Adams. The last named did much to popularise a more contemporary approach, but the great majority of the exhibits were traditional in design. It was what the American buyers wanted, or so the manufacturers believed.

When there was a desire to break away from stereotyped forms, Paris was often the source of design. A director or perhaps a sales representative would go, not to a pottery in Limoges, for example, but to a design studio in Paris and bring back a portfolio of drawings, not always of the highest level. These might be adapted freely, the colours altered and even a design translated into several differently coloured versions. Sometimes, distinguished artists, French or British, were commissioned to produce designs, for example, for a tea service, without having any direct contact with the actual production. There was, I believe, only one independent consulting designer in Staffordshire, Bennett by name, whose older brother, Arnold, drew on him for the young hero of *The Old Wives' Tale.* The younger Bennett had shown early brilliance as a sculptor, won a scholarship to the Royal College of Art and had an engaging personality.

Wedgwood, I (F.S.) was told, had made, without conspicuous success, a number of determined efforts over the years to break away from the domination of an over strong tradition. Generally speaking, it can be said that good shapes and excellent material and workmanship tended to be spoiled by too much and in-

appropriate ornament, achieving complexity without richness, and lacking in realisation that revival of the spirit which could have arisen only out of a more fundamental approach and the desire to achieve economy rather than the perpetuation of nineteenth century ostentation.

On the other hand it was the great age of the studio potters. Bernard Leach had several characteristic exhibits in the Government Pavilion, and W. Staite Murray showed some fine pots and bowls of stoneware, certainly of Chinese inspiration. There was an excellent small model of a jaguar by Stella Crafts but perhaps too many coy figurines from lesser studio potters. Moorcroft was a pottery that produced good quality work and is still in existence. The famous glass makers in England and Ireland, Blackfriars, Waterford and others, had achieved perfection in the whiteness and quality of the crystal, enhanced by skilful cutting. So, of course, had the Bohemian craftsmen and French firms like Baccarat. The hand made table glassware exhibited by James Powell and Sons of Whitefriars showed an extremely high quality of design and manufacture unsurpassed elsewhere in the exhibition. Other countries showed a great advance in the design of pressed and cast glass.

The display of British Architecture in the Grand Palais consisted mainly of photographs giving a representative picture of the work of the period, hardly any of which could be described properly as modern as interpreted by the French. We shall see that the direct influence of the exhibition on British architecture was brief and of minor importance. The work shown, however, did receive very favourable comment from the international jury for awards in architecture, and this reaction may be epitomised by the remark of one eminent French member to the effect that 'en regardant ces jolies maisons on a envie de la campagne.'

It was a pity that the work of Sir Edwin Lutyens, the foremost British architect of the era, could not have been included, as he had resigned membership in the RIBA after a difference of opinion, and the chairman of the selection committee was the RIBA President. Medium sized country houses typical of the 1900 to 1914 period, showing sympathy of house, garden and landscape by Guy Dawber, Oswald P.

Milne, Clough Williams Ellis, Darcey Braddell were typical of neither 'Art Deco' nor 'Moderne' but were broad-mindedly traditional and designed for comfort and agreeable living. The earlier generation was represented by sketches, drawings and photographs of the work of Baillie-Scott, C.F.A. Voysey and Henry Wilson.

Not inappropriately, there were in the same gallery, a few stands which displayed the level of perfection reached in articles of utility requiring a high quality of finish in ivory and tortoiseshell, morocco and all kinds of leather. The quality of design and workmanship of the combs and brushes, tortoiseshell spectacles (then becoming fashionable), suitcases, valises and handbags, cigar and cigarette boxes all received appreciative comment.

The education section showed work from a number of Art Schools of which the ones that are strongest in the memory are the paintings entitled *The Marriage at Cana* and *The Deluge*, both by Winifred Knight and showing an interesting and individual integration of Pre-Raphaelite feeling and Cubist concentration. These were shown in the section of the British School at Rome, the artist having been awarded the Rome Scholarship although her training was undertaken at the Slade School. The Central School of Arts and Crafts contributed high quality gold and silver jewellery, set with gems and designed by Dianne Adams.

The paintings referred to above could be classified as murals, an apt introduction to the work of George Sheringham who undertook a decorative chinoiserie in tempera and also livened up considerably the various British sections in the Grand Palais by applying colour to the standard Board of Works hardwood show cases and by decorating with original designs the wooden tubs containing bay trees that stood around. On a few of these he applied the Union Jack on all four faces. I (F.S.) remember him saying, noticing perhaps a look of surprise, 'people never realise what a good design it is.'

The frieze by Maurice Greiffenhagen, R.A., representing *Empire* in the Invalides, also deserves a comment. Tigers among the dancing girls, princes with jewelled swords, elephants hauling logs, tigers and jaguars are all legitimately juxtaposed into a vigorous composition, contrasting to the sincere but insipid allegorical frieze by A.K. Lawrence called *The Altruists*, which had been shown at Wembley the year before.

The space in the Grand Palais was inadequate to represent properly the art of the theatre in Britain in 1925. It was too small not only absolutely, but also in relation to other sections, and, in addition, was the wrong shape, much too narrow, in fact a corridor. These inadequacies made it impossible to give an impression of a production as a whole, as was done at the 'Covent Garden' exhibition at the Victoria and Albert

Museum in 1971 or 'Diaghilev' at Forbes House in 1954. Instead, this exhibit was split up into sections, separately showing drawings, costume designs, models of sets and photographs.

Space limitations may partly but not altogether excuse some inexplicable omissions, the most serious being the work of Gordon Craig, although some of his work had been displayed at Wembley. Claud Lovat-Fraser, whose designs for Playfair's production of *The Beggar's Opera* in 1921 were famous, was inadequately represented, as were the designs of Duncan Grant, while the epoch making 1912 productions of Shakespeare's *Twelfth Night* and *A Midsummer Night's Dream* by Granville Barker were not shown at all. Nevertheless, the section was interesting and most of what was exhibited was good, if not so sensationally original as some in the foreign sections.

Again, we come to George Sheringham who continued to work for Playfair at Hammersmith until the 'thirties, to Albert Rutherston and to Sladen Smith. The last was an interesting artist and was mainly employed as a textile designer in Manchester. His printed cottons at that time were intended solely for the export market in Africa and were not available in England before the mid 'thirties, when they became popular to a limited but discerning public. These fabrics showed a deep appreciation of African native tradition and had strong design. Sladen Smith was not only a stage designer but also a playwright and his work was produced at the Birmingham Repertory Theatre. Sets by Paul Shelving, long associated with this theatre, for *The Immortal Hour* and *Romeo and Juliet* effectively echoed some of Gordon Craig's ideas, while the first production of Shaw's *Saint Joan* continued the Irving-Tree tradition with schemes of superb quality. Oliver Bernard's work was well represented with his designs for *The Ring* at Covent Garden, and he was well in advance of his time not only in his use of electric light as a material of architectural expression which was applicable to any type of building.

The chapter on this subject by A.P.D. Penrose in the British Report of the Exhibition should be read for the succinct and very interesting contemporary appraisal of the state of the theatre in Europe as seen in this year, foreshadowing the developments of the following half century.

There was a very generous allowance of space in the Grand Palais allotted to the textile industries of Britain, but less consideration was given as to how it was to be disposed. The fine quality of manufacture and material in silk, linen, cotton and wool was exhibited by Warner and Sons, Morton Sundour, British Celanese, Tootal Broadhurst, Lee Turnbull and Stockdale, and Foxton, but, on the whole, there was little originality when compared to the French textiles by Raoul Dufy, Sonia Delaunay, Rodier and Paul Poiret, to mention only a few. Not until the

'thirties was there a revival of textile design in Britain.

Although the designs of William Morris were still popular, chintz and cretonnes with naturalistic flower patterns or ones derived from Elizabethan embroideries reigned supreme. Morton Sundour, in particular, could boast of the fast colours and high quality of their goods. For the richer fabrics, brocades and velvets, the ogee patterns of the Renaissance were almost universal along with Regency stripes and other classical themes. Again, the chenille tapestry materials for upholstery looked almost exclusively to traditional models, perhaps not unreasonably as the design of furniture remained virtually unchanged. It may have been indicative of the national temperament that the few artists who responded to the search for a contemporary idiom should have been more drawn to an appreciation of abstract form than to the stylisation of floral motifs that was typical of Art Deco in France.

Stage set by Oliver P. Bernard for Das Rheingold

The Forty Thieves

At this point it is perhaps not inconsistent to give a personal account of the setting up of the British Textile Section at the Grand Palais with which I (M.T.) was concerned and which, after fifty years, still moves me to laughter. I also continue to be astonished at my youthful audacity and optimism in undertaking the job at all.

I was encouraged to submit two textile designs, both executed by Courtaulds, for exhibition in the British Section in 1925. These were accepted, and, later, I was sent for and asked if I would execute the murals designed for the Textile Section by the well known Academician, Robert Anning-Bell. Of course I agreed and was pleased and flattered, though it must be admitted that the fact of my being on the spot, so to speak, was more than half the reason for the choice. To my chagrin, I heard nothing more. As it was March by now, and the great Exposition was due to open in April, I saw no point in staying behind when my parents went for a short holiday in the

south of France. A communication, however, reached me at Hyères-les-Palmiers, and I hurried back to Paris. On April 3, I received a telegram asking me to call at the British Pavilion immediately. I went and was told that the official opening of the British Section by Prince Arthur of Connaught would take place early in May, that Robert Anning-Bell's designs for the Textile Section had now arrived and would I please begin. The Section occupied three of the largest rooms in the Grand Palais. The small sketches were designed to be painted directly on the upper walls now covered with hessian and comprised panels to be enlarged to sixteen panels, eight feet in height and twelve and six feet in width. It was too late and too expensive to erect scaffolding: I had to paint the panels on the floor, and they were put in place when completed. I pointed out that, technically, this was most unsatisfactory. I should find, they said, a large roll of canvas and some charcoal in the main room. 'We shall need a little help', I murmured, which was certainly the understatement of the year.

I duly went to the first floor of the Grand Palais, familiar as the scene of the annual painting exhibition of the Salon des Artistes Français, where I found an immense roll of canvas and the promised box of charcoal. I think that I sat on the canvas and endeavoured to assess the problem. In the end, I returned to the pavilion and obtained permission to put up notices in some of the art schools asking for students to help in the execution of the murals for a modest fee per hour. This was a very welcome offer, as I knew it would be, the average student being nothing if not impecunious. I very quickly recruited forty boys and girls of varying nationalities, whom I came to term affectionately my 'forty thieves'. They were grand and worked with a will, in shifts, as far as I remember, for at least sixteen hours a day. There was never a sign of disagreement or difficulty in spite of their diverse origins. There were Russian refugees and a young couple, French I think, who rather ostentatiously painted the hammer and sickle on their paint stained overalls.

Early in the proceedings a party of French officials came through apparently on a tour of inspection.

Stage set by Oliver P. Bernard for Die Walküre

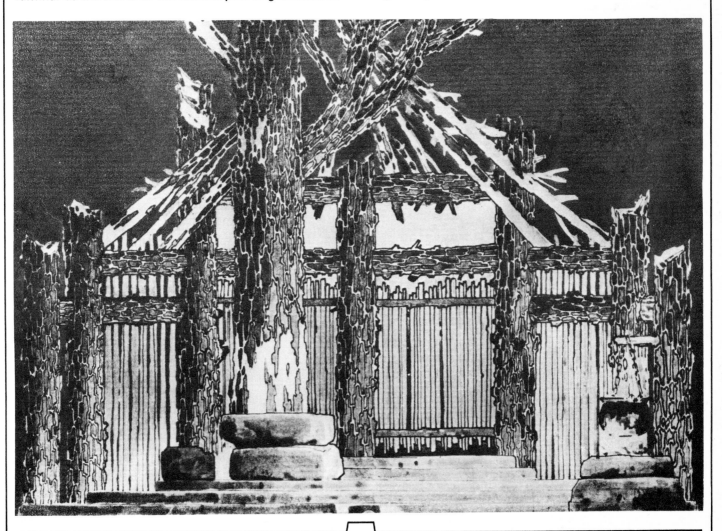

'And how, Mademoiselle, do you propose to affix these panels on the wall?' one gentleman asked. I answered respectfully that I hadn't a clue but that I had been told that when finished, they were to be stuck on the upper walls. He just laughed and presumably went to discuss the matter with the British Commission. I heaved a sigh of relief when the order came that our panels were to be put on wooden stretchers and eventually framed and hoisted into position. This was an obvious solution but one that still must have been disappointing to the designer who had envisaged the shapes and lettering painted directly on the walls.

Our huge canvases were then nailed on the stretchers and the surface squared by the simple method of attaching a piece of string across the measured points and tautening it. The string was then covered with charcoal, lifted a fraction and allowed to snap back. The result was a straight black line. When this process was completed, the original design, also squared, could be copied without difficulty and the painting begun. The paint used was that known as 'à la colle', the powdered dry colour being mixed with warm glue. We had some sort of stove on which to keep the glue in a liquid state, and the colours were prepared by the bucketful in order to maintain an even tone. There was a tense moment when Bella, the night watchman's dog, had a meal from the bucket of green paint. Not unnaturally, she was sick, very sick. Mercifully and miraculously, she recovered. Bella was a bitch of character. Unbelievably ugly, she was supposed to be a German bulldog, having a long snout and a tawny coat. Rumour had it however that she had been sired by a famous British bulldog owned by the Embassy in Paris and which was reputed to smoke a pipe. Be that as it may, her appearance alone was enough to scare any intruder but in point of fact, she was gentle enough. Her master, the night watchman, was a Russian émigré, a kind and cultured man who had been driven from his home by the Bolsheviks and succeeded in making his way to France. He supplemented his slender income by making the kind of painted boxes for which Russian craftsmen were famous. I have one to this day which is still a delight to the eye.

We slogged away, day and night, and the panels were finished only just in time for the official opening with about twenty four hours, if I remember rightly, to clean up and to arrange the exhibits. There were some recesses in the angles of the rooms, and these unaccountably had been painted puce with bay trees in square tubs tastefully placed inside them.

The 'forty thieves' turned up in force and soon cleared away the accumulated debris. We then unpacked the exhibits, which proved to be woefully sparse, and I was at my wits' end as to how to spread them out in the three vast rooms. We did succeed in putting up some sort of a show, and I had just time to go home and change into suitable attire for the ceremony.

Prince Arthur of Connaught came in due time to inspect the Textile Section. He congratulated me most kindly in a few choice words. His equerry, however, drew me to one side. 'We congratulate you even more', he said, 'we were here this morning incognito. . .'

A letter from the British Embassy in Paris, dated 20 May 1925, was addressed to the Commissioner General:

'Prince Arthur wishes you to convey on his behalf his great appreciation of the manner in which the whole of the staff employed in the preparation of the British Section completed their works. He was able to see for himself how much was done during the last few hours. Such results could never have been achieved without a healthy spirit of real enthusiasm, which he is convinced will animate those responsible and employed in the British Section until the close of the Exhibition.'

Robert Anning-Bell, R.A., whose designs we had executed, gave me and the 'forty thieves' a special dinner to commemorate the occasion, a kindly gesture from a most kindly man. As for me, I continued to be in charge of the Textile Section and had a little office in a cubby hole opening out of the principal room. There was a great deal more to do as the totally inadequate exhibits had to be supplemented hastily from the manufacturers in England and new stands erected for their display.

Indeed, it was not long before protests at the inadequacy of the Textile Section were to be heard, emanating particularly from north country manufacturers, who commented unfavourably on both the small number and the unrepresentative character of the exhibits. Quick action on the part of Sir Frank Warner, the chairman of the textile committee, produced a quantity of materials from different sources, but the problem then arose of displaying them to the best advantage. It was to a French designer, Maurice Dufrêne, that the Commission turned for advice, and I remember being told to impress on him the need for extreme economy, for by that time funds were running low. At his suggestion, islands arose in the centres of the vast rooms with an ingenious design of large Greek keys of silvered wood from which the products of the British looms were hung.

The quality of these fabrics was superb and, at least from that point of view, we had something to boast about. Equally impressive were Warner's magnificent imitations of Renaissance velvets and damasks. It was a pity that they hardly fitted into the Exposition's terms of reference, but this was sadly true of so many of our exhibits. In the climate of opinion then prevailing in England this was, of course, inevitable, and, at any rate, it can be said that we had little use for shoddy productions in those far off days.

So many people passed to and fro in the galleries of the Grand Palais, Parisians of course, but also sight-seers from all over the world. I remember the bulky figure of Paul Poiret, his shrewd little eyes almost sunken in rolls of fat, an appearance which belied the delicacy of vision, the amazing colour sense and the adventurous techniques that have made him legendary. Raymond Duncan, brother of the famous Isadora, was also a memorable figure in sandals and a tunic of grey home-spun. I can see him now, kneeling to examine some handwoven cloth and looking for all the world like a Biblical shepherd.

Maurice Dufrêne, dapper, business like and practical, Paul Follot, tall and elegant, René Lalique, older and with a trim beard, all men of great achievement and understanding, visited the galleries. Times were changing; not for them the Paris of Murger, of the 'Vie de Bohème', which however, still lingered on in what was left of the Latin Quarter. My 'forty thieves' would know it well. It is surely remembered with nostalgic regret as it recedes still further into the shades.

A few of 'The Forty Thieves' shortly before the Exhibition opened, with Marjorie Townley with a hat in the centre

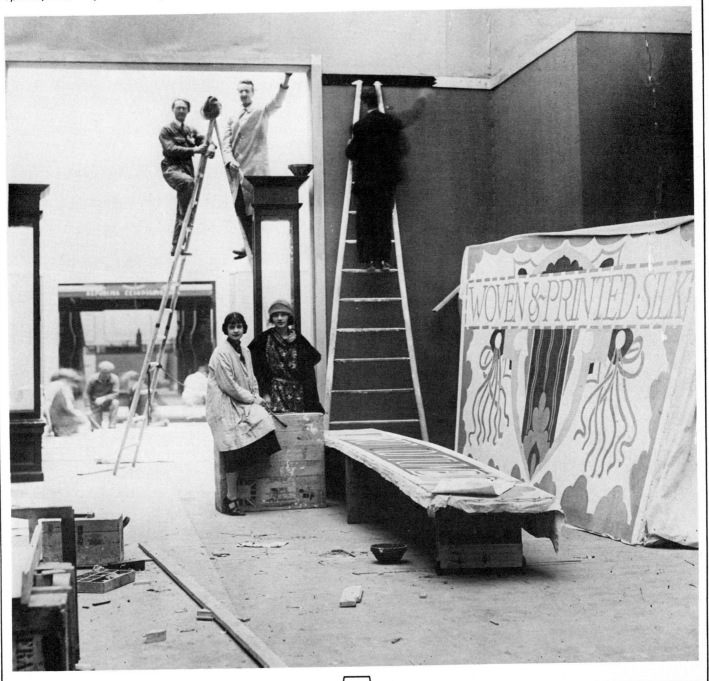

FOREIGN SECTIONS

Italy

With the triumph of Fascism, the desire to renew the Roman Empire and classical architecture animated those who supported the regime. Instead of displaying the work by Annibale or Raymondo d'Aronco, which would have expressed the spirit of the exhibition, the Italians erected next to the British pavilion a monumental horror of illiterate classicism with marble columns and gilded brickwork that would have disgraced Caligula. The British contribution was enhanced by contrast, although some visitors from Britain were heard to compare their own pavilion unfavourably with the Italian.

The interior was dominated by an over life-sized bronze bust of Il Duce, but otherwise there was little either relevant or interesting, although the official British report mentions that 'in the interior was a fine 17th century room. . . the inspiration was essentially baroque'. Only in theatrical design, with the work of

Workers' Club by Rodtchenko in the Russian Pavilion

Prompolini, was it apparent that Futurism had not been entirely forgotten, although perhaps the Fiat factory in Milan with a race track on the roof should be mentioned as a legitimate expression of the desire to symbolise the rebirth of the Roman spirit. The factory was illustrated by photographs in the architecture section.

U.S.S.R.

There could not have been a greater contrast to the Italian Pavilion than the Russian Pavilion by Melnikov, which expressed the aspirations of the revolution in an exciting and spontaneous manner. It was a constructivist and romantic building, built of inexpensive materials on a minimal budget. Konstantin Melnikov died in Moscow, December 1974 aged 84, and, in the fifth International Exhibition in Milan in 1933, a special section was devoted to his work along with that of Frank Lloyd Wright, Le Corbusier and Walter Gropius.

Inside, a workman's club by Rodtchenko, showed Spartan austerity and there was much peasant art in textiles and pottery and a high level of imagination in stage settings for *St. Joan, Phèdre* and *Lohengrin* by L.F. Popova and W. Meyerhold for *Le Cocu Magnifique* (Commelynch).

The architecture section in the Grand Palais showed drawings of constructivist and mostly unrealisable projects including the mile high monument to the Third International, by Tatlin, of which there exists a scale model in London, shown recently at the Hayward Gallery.

Of course, there must have been pre-1917 expressions of the spirit of the Exhibition in the decorative arts which it would have been very interesting to see.

Poland

The architect of the Polish Pavilion, Joseph Czarkowski, planned the building on a longitudinal axis with entrances at either end and a central octagonal court crowned by a glass and metal tower standing on timber columns. I (F.S.) have neither recollection nor photographs of the sides but both the ends were of striking originality and beauty. The main front and the tower were reflected in a rectangular pool of extreme simplicity gauged exactly to contain the inverted image of the glistening facets of the tower.

From the other side through wrought iron gates of strong and simple design, one entered a cool atrium in which a marble figure, *Le Rythme* by H. Küna stood surrounded with mural decoration by Wojciech Jastrzebowski, who had studied at the Cracow Art

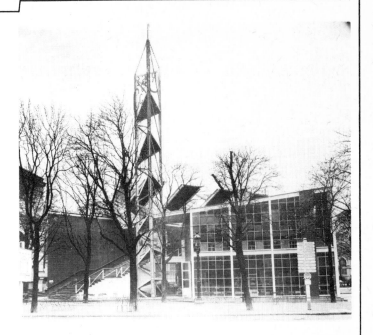

A general view of the Russian Pavilion (above) with entrance (below)

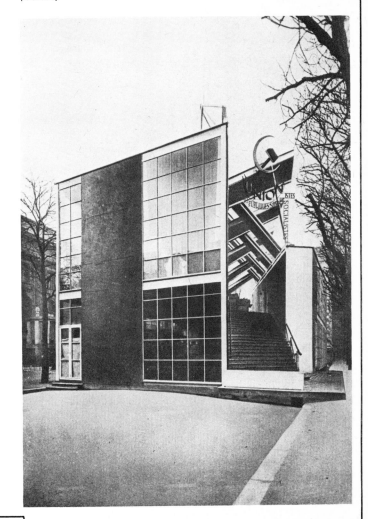

Academy for a few years before World War I and later became a producer of art handicraft. To quote from George Sheringham, 'This decoration be it said at once was essentially Polish and entirely delightful; a more adequate decoration it seemed impossible to conceive. . . The walls were cement-faced and evidently before dry, entirely covered with black fresco paint; the pattern was scraped ('Sgraffito') with some simple tool with great freedom and necessarily with speed, revealing again the colour of the cement and (as in the similar art of the Chinese Coromandal screen), a few touches of simple colour painted on the scraped panels and the entire decoration was complete.'

Above the pavilion rose the glass and metal tower which symbolised the resurgence of a valiant nation, thrice occupied and partitioned, yet always maintaining an intense nationalism and spiritual identity. The equally symbolic tower (by J. Cybulski and R. Calinowski) of the Polish Pavilion at the exhibition in New York in 1939, also reflected in a pool, again expressed the spirit of the nation.

The faceted design of the 1925 tower is peculiarly Polish, as exemplified by the vaulting in some mediaeval churches, composed of flat surfaces as opposed to the curved surfaces contained by ribs of western Europe. Such vaulting is seen in the gothic Vilno Bernardin Church, the Parish Church of Lomza and the 15th century church at Ketrzyn. There may be some Persian influence since similar vaults occur at the Gold Iwan of Ali Shir Nawai and the Qaysarya Bazaar of Isfahan. It may also be that the design arose in both countries from the use of brick for building vaults because of the shortage of good building stone. The same kind of elaboration without curved forms is seen in the carved wooden panels of the doors to the courtyard where, of course, such decorative motifs are equally suitable for the use of the chisel.

The portion of a chapel with carved wood decoration and altar shown by Jean Szepkowski had great energy and power of expression. The overall

Stage sets by L.F. Popova for Meyerhold's production of Le Cocu magnifique

The Polish Pavilion (Joseph Czajkowski, architect)

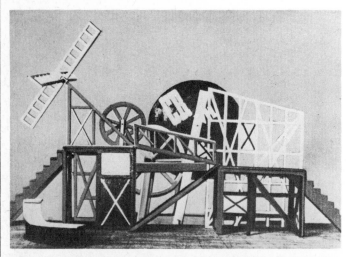

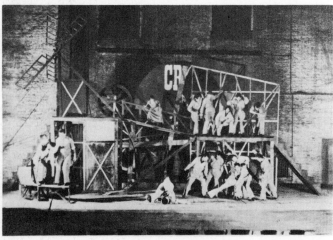

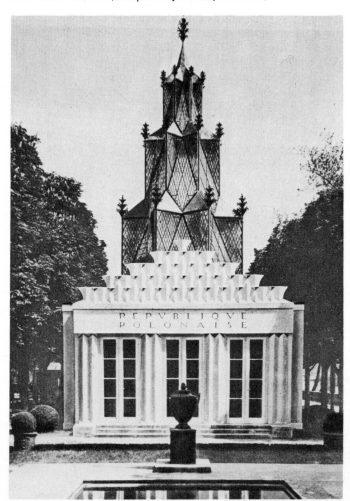

impression with its deep cut facets had some resemblance to the Cubist paintings of Picasso and Braque, although actually the design arose out of a strong peasant tradition. The artist was Director of the Warsaw School of Decorative Art and Painting.

In the field of painting, it was Sofia Stryjenska's work that made the greatest impact on the Exhibition as a whole. This gifted woman artist (née Lubanska) was born in 1894 and achieved early success in the years from 1922 to 1932, when she was leader of the then fashionable Rhythm Group. I quote my friend Marceli Karczewski: 'Her enormous vitality and romanticism found a wide field of expression in the Polish traditions, legends, customs, etc. Movement is a dominating feature of her paintings.' The central hall of the Pavillon d'Honneur was decorated by her panels representing the months, with figures illustrative of the seasonal activities, boldly patterned and strongly coloured. Elsewhere in the Exhibition, there were book illustrations and tapestries by her hand. Her work, though I am told it had nothing in common with the Ecole de Paris, continued the Polish traditions, developing it into a new and entirely personal expression.

Tapestries and rugs designed by Czarkowski, Kossevstska and others and executed by the Society of Popular Arts of Warsaw and the ateliers of Crakow showed the same vigorously primitive approach.

From what has been said, it will appear that, in my (F.S.) opinion, the Polish was the most inspiring national contribution to the Exhibition and showed the decorative arts in a manner expressive of the soul of the nation. If architecture is frozen music, then it had the fire and passion of Chopin.

The Netherlands

But if the Poles distilled perfectly the spirit of their nation, who would have expected that when we come to the Dutch Pavilion, that trim, tidy, sober, Calvinistic little country, where the landscape looks as if it had been designed by Mondrian on squared paper, would have produced such an ebullient masterpiece of expressionism? The exterior was carried out in exquisite and perfectly laid brickwork. The motif of the gable end was a sailing ship riding proudly through the waves with just the word HOLLANDE, all in brick,

Two views of the courtyard of the Polish Pavilion showing marble figure Le Rythme *by H. Küna and (right) sgraffito wall treatment*

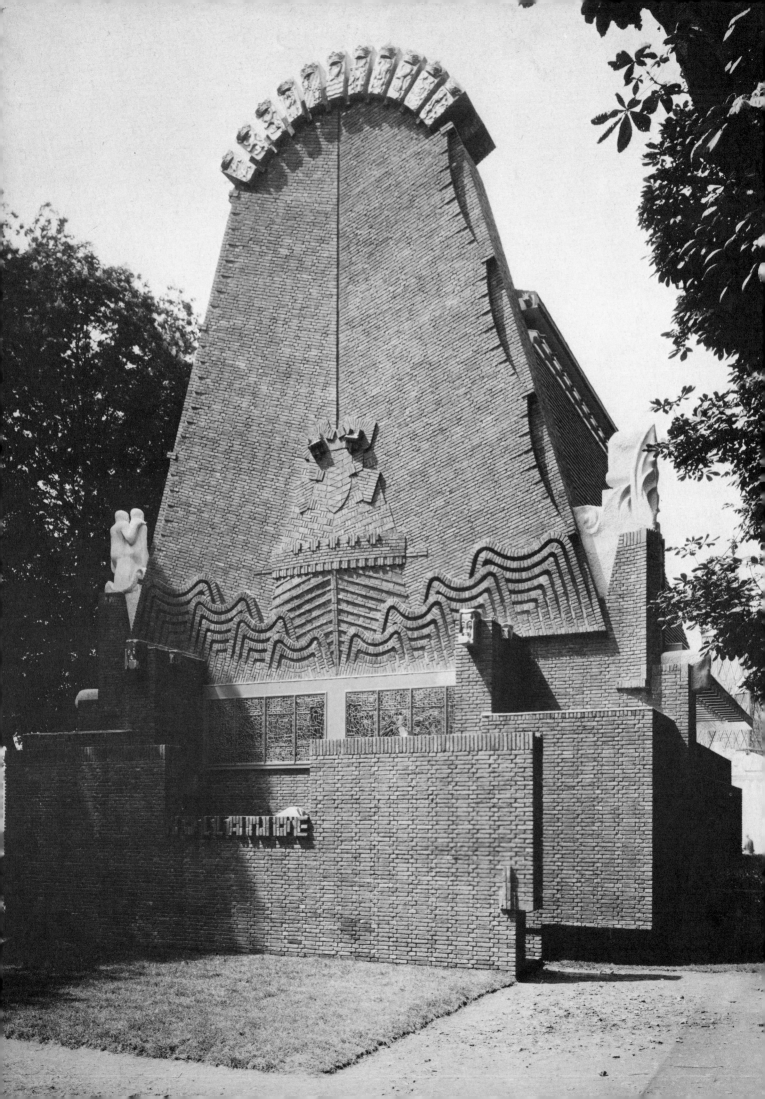

apart from some stone sculpture. The lower part was a composition of abstract brick rectangles, and I (F.S.) remember being slightly shocked as was Howard Robertson, the architect of the British Pavilion, by the corners, which had no apparent means of support. In spite of the surprise the building gave, it would have looked perfectly in scale and appropriate overlooking a canal in Haarlem or Delft.

Inside, however, was heavy cubist furniture, much too architectural, apart from a study by H. Wouda. De Stijl was not represented although the organiser was editor of an avant-garde review, *De Vendigen.*

Austria

Josef Hoffmann was appointed head of the Department of Architecture after the resignation of the Directors of the Imperial School of Arts and Crafts in 1899 and the following year was in charge of the Austrian sections at the Paris Exhibition.

He worked with Olbricht and Klimt on the Se-

cessionist Building, still to be seen in Vienna and twenty five years later was again the architect appointed for the Paris Exhibition.

Whereas the tenor of Art Nouveau seen in the earlier exhibition was undulant, sinister, and dark in spirit, the representation in 1925, after the Hapsburg Empire had been reduced to little more than a city state, expressed gaiety, if not happiness. Vibrant colours, as seen in the Wiener Werkstatte wall papers, replaced the sad greens and blues and the jaundiced yellows prominent in 1900. The main exhibition hall was of the simplest design, built in timber faced internally with paper, externally clad in concrete of elegant form.

The Organ Tower of Strnad; the metal and glass hall, where abstract metal forms and hanging lamps with growing flowers and tropical plants informally blended into an ensemble; the riverside Café Viennois with its figures in pottery, where one enjoyed delicious ice cream and the most excellent coffee, all had charm and fantasy which was the product of vitality coupled with intellectual restraint. 'La Flamme Humaine', a bronze by Anton Hanak in the entrance hall, perfectly

(left) The Pavilion of the Netherlands

Le Café Viennois

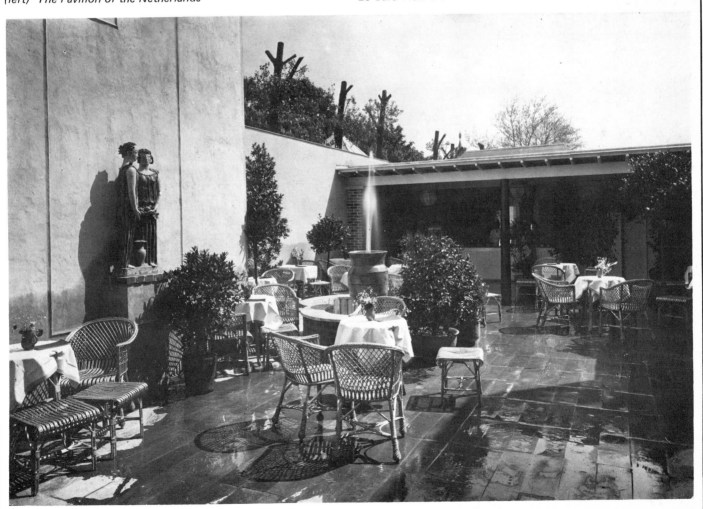

expressed the spirit. The Room of Relaxation by Hoffmann had no chairs or other furniture but a deeply upholstered floor and cushions. Niches in the walls took the place of tables, and the ensemble showed the most advanced thought in interior design in the whole Exhibition.

Sweden

This pavilion was the most classical building of all, while, at the same time designed with the utmost simplicity, disturbed only by the bas-reliefs on the entrance wall. It was almost archaic in feeling and was not in the least 'modern' but instead constituted further development of the Thorwaldsen tradition. The main entrance was under a portico reflected in a pool surrounded by stone paving on which stood a fountain in black granite surmounted by a Carl Milles

figure in white marble and some superb cast iron pots by Ivar Johnson and Rolf Bohn. A side entrance from the Cours La Reine lead to a circular domed vestibule on iron columns with map decoration on the walls.

The most striking exhibit was that of the Orrefors Glass works. Previously producing standard commercial glass, the works were taken over in about 1917 by Johan Ekman, who employed the best designers he could find, Simon Gate and Edward Hall, to produce work of quality. The finest engraved show pieces were displayed as well as inexpensive table glass for everyday use, which became popular for many years all over Europe. Time has done little to diminish esteem for the lightness and grace and virtuosity of the engraving. The hand woven rugs, carpets and other textiles showed that the traditional crafts were very much alive to new sources of inspiration without loss of quality.

As in the architecture, extreme simplicity and

The organ tower of the Austrian Pavilion

(right) The conservatory in the Austrian Pavilion

Rest room by Joseph Hoffmann in the Austrian Pavilion

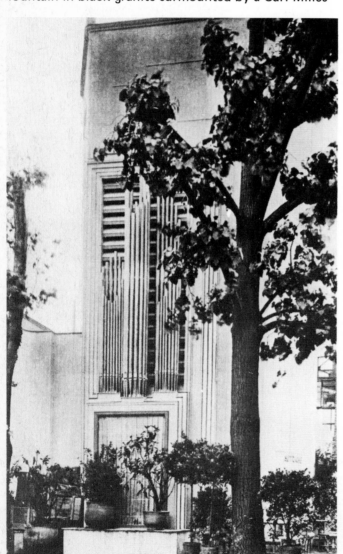

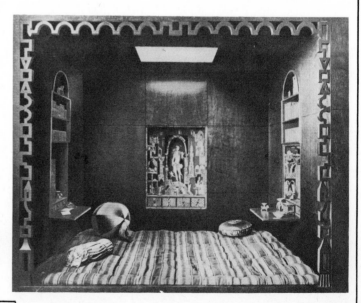

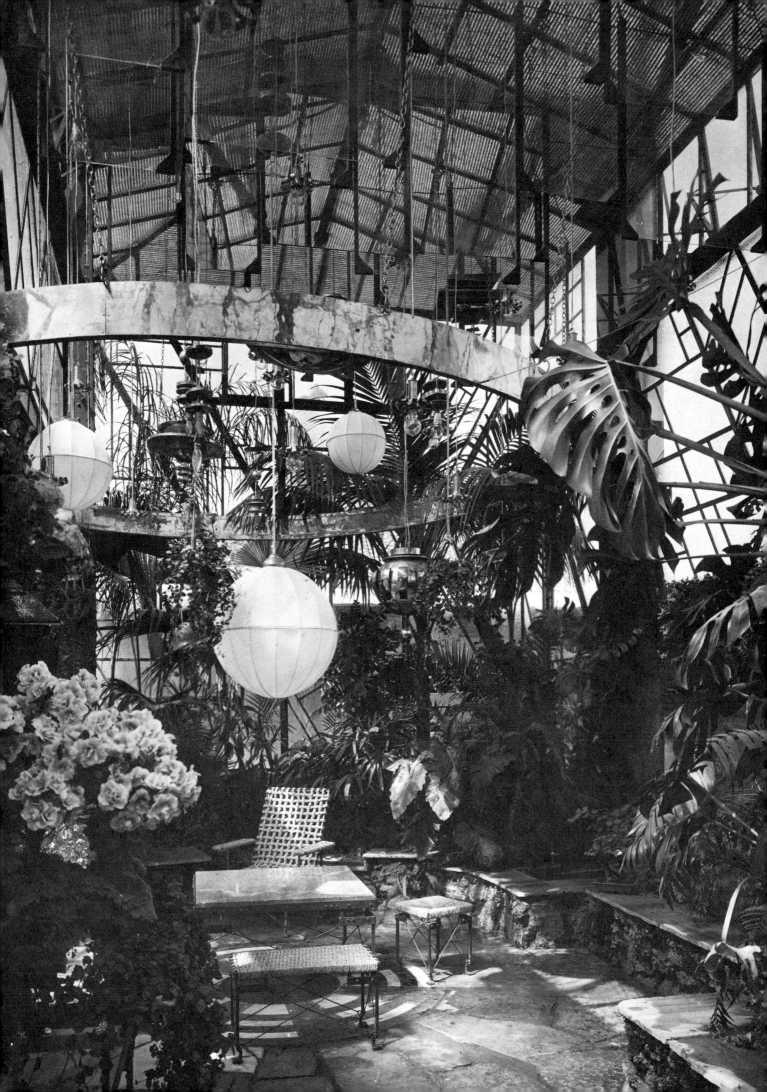

86

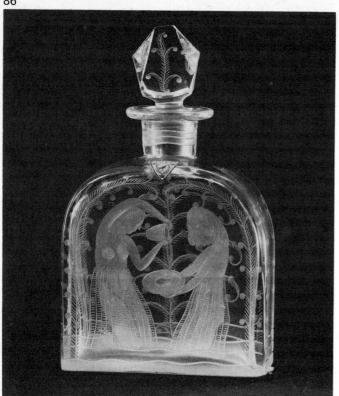

Flagon by Orrefors (Sweden). Engraved crystal

Living room by Carl Malmsten

Title page by George Barbier from Falbalas et Fanfreluches

Dress by Poiret, illustration by Marty

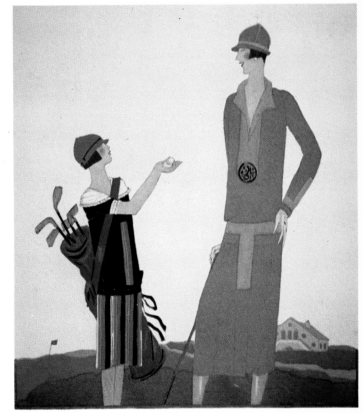

Le Cady improvisé, *dress by Lanvin, illustration by Lepape*

restraint founded on traditional forms was seen in the ensembles of furniture which also reflected the perfection of workmanship. While the quality of the whole was of a very high standard, it cannot be said to have made a significant contribution to modern design or to furthering the ideals that were the impetus of the Exhibition. They constituted a reaction towards tradition and good taste and against the more liberal Högalid Church and Stockholm City Hall. Their designers, Uno Ahren and E.G. Apslund, devised some charmingly simple and restful interiors, the chairs in most cases being particularly well designed.

Denmark

This small pavilion can only be described as an example of the 'modern monumental' in the form of a cross standing on a square, built in brickwork with every other course recessed, windows on each arm of the cross deeply sunk into brick jambs so that the effect, except on a direct view, was monolithic.

(left) Mural by Sofia Stryjenska in the Polish Pavilion

While Sweden excelled in glasswork, Denmark's main achievements were in pottery, shown in two pavilions on the Esplanade des Invalides, one for the Royal Copenhagen Porcelain Factory and the other for Bing and Gröndahl. The Copenhagen building was very simple. Its main front was convex and glazed in small panes of glass with a central door. Bing and Gröndahl displayed most impressive work by Jean Gauguin (son of Paul), in 'slagger' mixture while Kai Neilsen, in the Copenhagen exhibit, showed small white porcelain figures such as are still produced. Jensen silverware had the same elegance of design that is seen today.

Japan

The Japanese Pavilion was modest in character, national in style and provided an early example of prefabrication. The parts, mainly timber, were manufactured in Japan and erected in Paris by Japanese. The re-interpretation of tradition under western influ-

The Pavilion of the Royal Copenhagen Factory

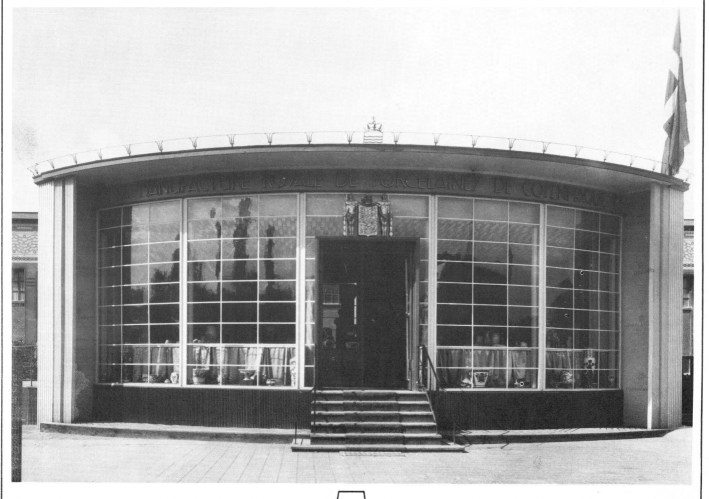

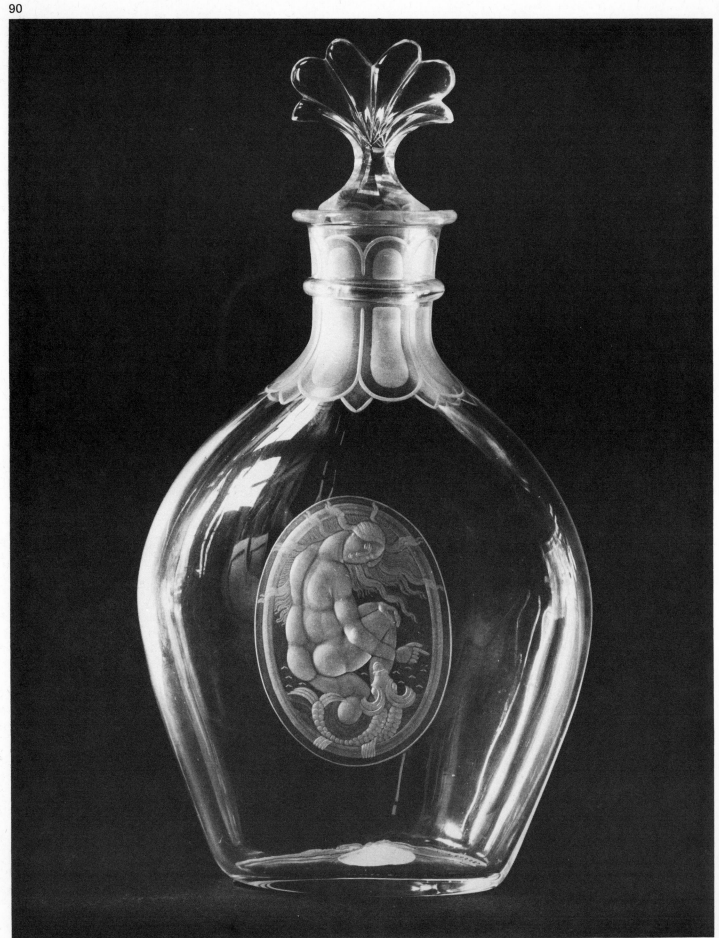

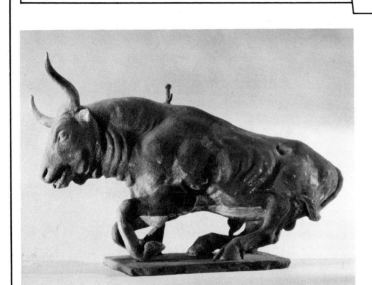

ence, so evident in their work after World War II, was not then apparent. Craftsmanship in timber was entirely traditional in manner and reached a high standard. The restaurant, detached from the Exhibition building, showed how a rectangular hut with a thirty degree pitched roof could, with selective taste in the arrangement of standard elements, become an interesting building. The national spirit was again expressed in the garden by bamboo and dwarf trees. The architects were Shichigor Yamada and Iwakichi Miyamoto.

Monaco

The Monégasque Pavilion by J. Médecin consisted of a single lofty hall, entered through three pairs of glazed bronze doors from a white stucco exterior. Slender reeded pilasters framed large scale sgraffito panels. Traditional in feeling, the whole was charmingly evocative of the Midi, with hydrangeas in big faience pots. In the sgraffito decoration by J. Bouchon, the surface was incised, and only the cut

Wounded Bull *by Jean Gauguin*

(left) Carafe by Orrefors (Sweden). Engraved crystal

The Pavilion of the Royal Copenhagen Factory, side view

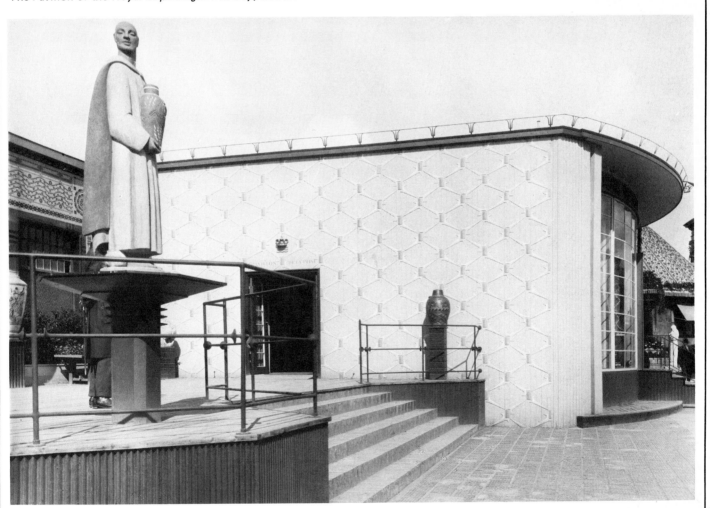

away portions blacked, the ground being left white.

It is a pity, but we have no recollection of the exhibits.

Czechoslovakia

Perhaps because it was a new country, the pavilion of Czechoslovakia owed little to tradition. It was, nevertheless, a striking conception with some debt, perhaps, to German influence. For one thing, it accepted the limitations of the site more easily than most. The sites of pavilions ranged along the Cours La Reine and facing the river were, owing to the narrowness of the approach road, not wide enough to develop properly their major frontage. In this respect, the British were most favourably treated in that the main entrance, which was at the east end of the pavilion, faced the Place Alexandre III and, moreover, it was possible to expand to the south with the restaurant. The Czech

pavilion presented a bold face like the prow of a great ship towards the east and in other than a land locked country, particularly if a great naval power, it would have seemed conscious symbolism, if not aggression. The pavilion was, however, most striking and allowed an extremely functional layout of the entrance with a bold projecting canopy asymmetrically disposed on one side of a column, almost keel like, to continue the nautical analogy. The central projection was faced with crimson coloured tile and crowned by a figure.

As would be expected, there was a very considerable and well displayed exhibit of glass, particularly tableware, much of which was coloured and elaborately engraved and all of a very high technical quality. There was also a display of china and

The Czech Pavilion by J. Gocar

The Pavilion of Monaco

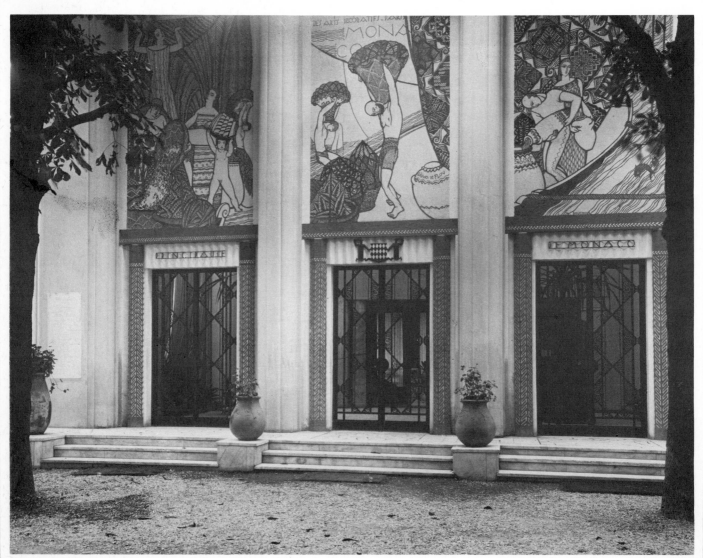

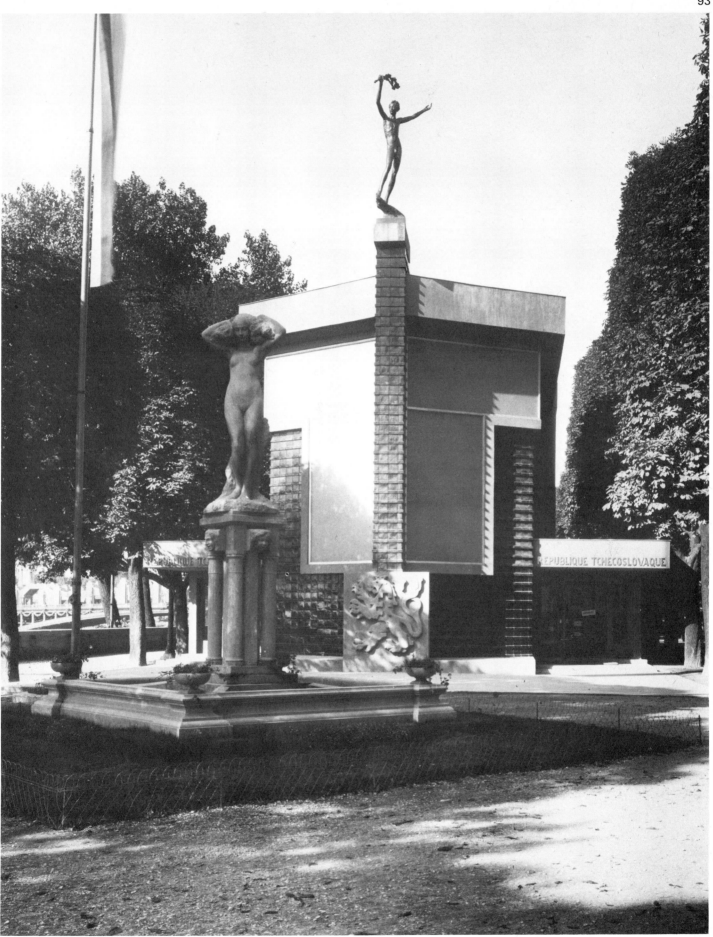

earthenware of good standard. The Czech achievement in textiles was represented on the upper floor by carpets and tapestries designed for the President's house. According to the British Report, the carpet was hand-knotted woollen pile covering 100 square metres and made at the direction of M. Beneš by men disabled during World War I. As photographs are not available, it would be tedious to try to describe the tapestries, lace work and other textiles that were shown, but some of these were evidently of great originality.

Belgium

Art Nouveau seems to have developed as far if not farther in Belgium than in any other country. It might be said that the Belgian pavilion showed a strong reaction in a basically neo-classic direction. It is, however, interesting that the building had been designed by Victor Horta, who had played such a leading part in Brussels in the development of Art Nouveau and the Libre Esthétique movement. A council room carried out by the Ateliers d'Art de Courtrai had been set up with rosewood panelling, wrought iron doors and a massive chimneypiece of green marble.

There were finely modelled silver tea and coffee pots and other tableware exhibited in the pavilion by Phillipe Wolders. As would be expected, the needle point and point de Venise was superb. Interesting mannerist bird panels in monochrome were displayed on the walls.

Greece and Spain

Greece was represented by a conventional villa, as was Spain. Many architectural features in both produced a fussy effect suggesting the nineteenth century rather than recreating the native traditions in a contemporary expression. A panther sculpted in diorite by D. Mateo Hernández was placed in the garden of the Spanish pavilion.

It will be seen that each of the national pavilions represented their countries in a different manner and that their designers had individual interpretations of what was modern. In consequence there was no overall unity of architectural effect although the compensations offered by lack of monotony and diversity of character were considerable.

THE AFTERMATH OF ART DECO

Howard Robertson, who, as we have seen, designed the British Pavilion, would seem to provide an appropriate starting point for this section. He was born in Salt Lake City, U.S.A., trained as an architect at the Ecole des Beaux-Arts, Paris, served in the British Army and was awarded a Military Cross in World War I and established himself in practice in London until his death in 1963. Robertson was one of the kindest and nicest of men and could not do enough to help younger architects and promote the cause of progressive architecture. During the early 'twenties, he wrote a weekly series of illustrated articles in *Architect and Building News* which did much to familiarise the profession with work that was progressive in spirit, some of which disturbed older architects. I particularly remember one, for whom I was working at the time, being horrified by Perret's garage in the Rue Ponthieu which was demolished only quite recently. Robertson succeeded Robert Atkinson as Principal of the A.A. school and also ran a busy practice in partnership with J. Murray Easton.

A few years after the Exhibition, Easton and Robertson's firm carried out an extensive programme of modernisation at the Savoy Hotel and Theatre, much of which can still be seen, which I would describe as Art Deco at its best. The predominant characteristics are dead white walls, lavish use of mirrors, particularly circular ones, rough textured woollen upholstery fabric and tubby arm chairs. Externally, the Strand entrance was canopied in stainless steel and the Embankment entrance in shell concrete, both of which remain. It is a tragedy that Howard Robertson's last few years should have been clouded by adverse criticism, one might say abuse, of the Shell Building by younger 'modern' architects, for whom he had done so much. Easton and Robertson also undertook some remodelling of the interiors of the old Berkeley Hotel in Piccadilly. Oswald P. Milne carried out similar work in Claridge's. His mode was rather more restrained and classic and, as one would have expected, in very good taste.

Art Deco did not become an immediately popular style for British architecture. The ideas and principles of the Bauhaus exerted a stronger appeal. What is perhaps the most striking example of Art Deco in London came by way of America in Palladium House, Great Marlborough Street, which Nikolaus Pevsner describes as 'an architectural parallel to the Wurlitzer in music—black sheer granite and rich gild with lush floral motifs of the Paris Exhibition of 1925'. This building is, in fact, a small version of a similar one in New York for the Ideal Radiator Company by the same architect, Ray Hood, who suddenly had become famous by winning an international competition for the Chicago Tribune Offices with a design inspired by the Flamboyant tower of St. Ouen, Rouen.

One of the most interesting buildings of the early twentieth century in the United States is the State Capitol at Lincoln, Nebraska, by Bertram Grosvenor Goodhue, who was the best architect of the later Gothic Revival that America produced, in my opinion, as good as J.L. Pearson in England. There is indeed some similarity between Saint Augustine, Kilburn, by Pearson and the Church of Saint Thomas, Fifth Avenue, New York by Goodhue.

In the Nebraska Capitol, Goodhue abandoned the Gothic and sought a new expression. The State of Nebraska is unique among the United States in having a unicameral legislature, and it was therefore appropriate that it should be expressed by originality in the architecture of its State Capitol. The design is doubly interesting in that it was a complete break with the style of the life work of a highly gifted and successful architect. The method of selection of the architect was also original. It was decided in 1919 that a competition should be held under the aegis of Thomas Rogers Kimball, who stipulated that the names of the assessors should not be published until after all the designs had been sent in. Goodhue read the programme as a direct message from Olympus and said that never had he in any competition been set as free as in this (*The American Architect*, Vol. CXLV, September 1924). Another factor probably unique, was that the building was paid for entirely out of income from State revenue and, this perhaps was why it took twelve years, from 1920 to 1932, to erect. It is sad that Bertram Grosvenor Goodhue should have died in 1924, at the relatively early age

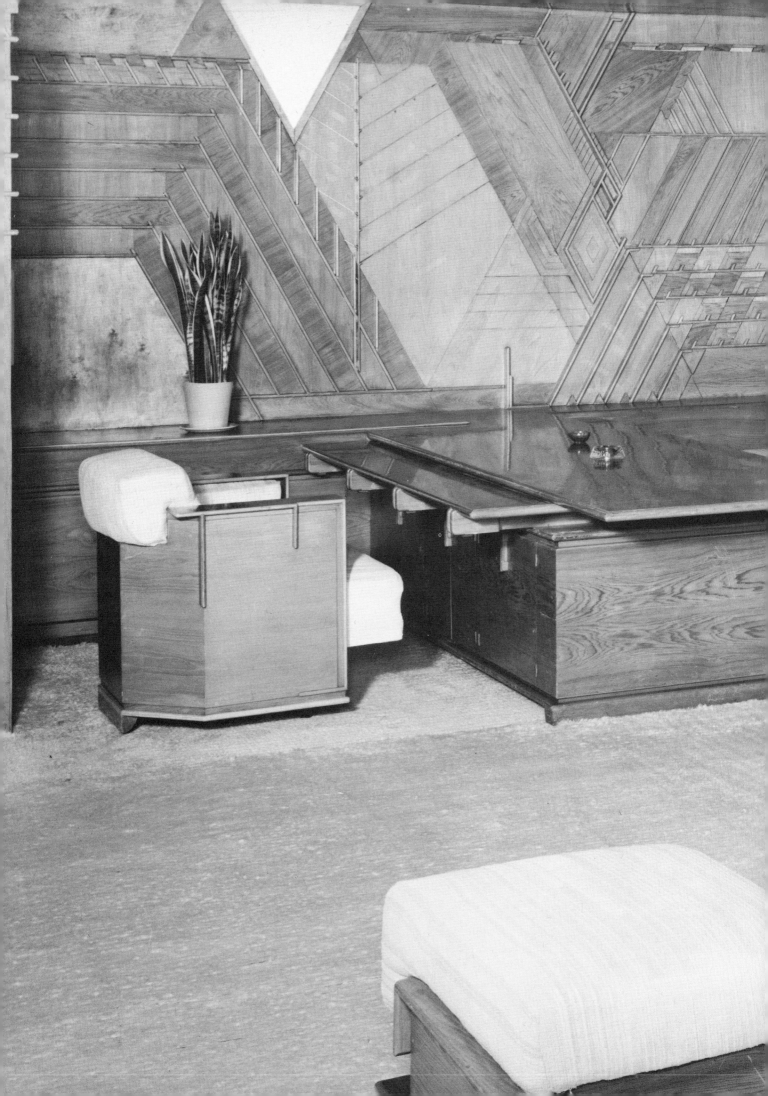

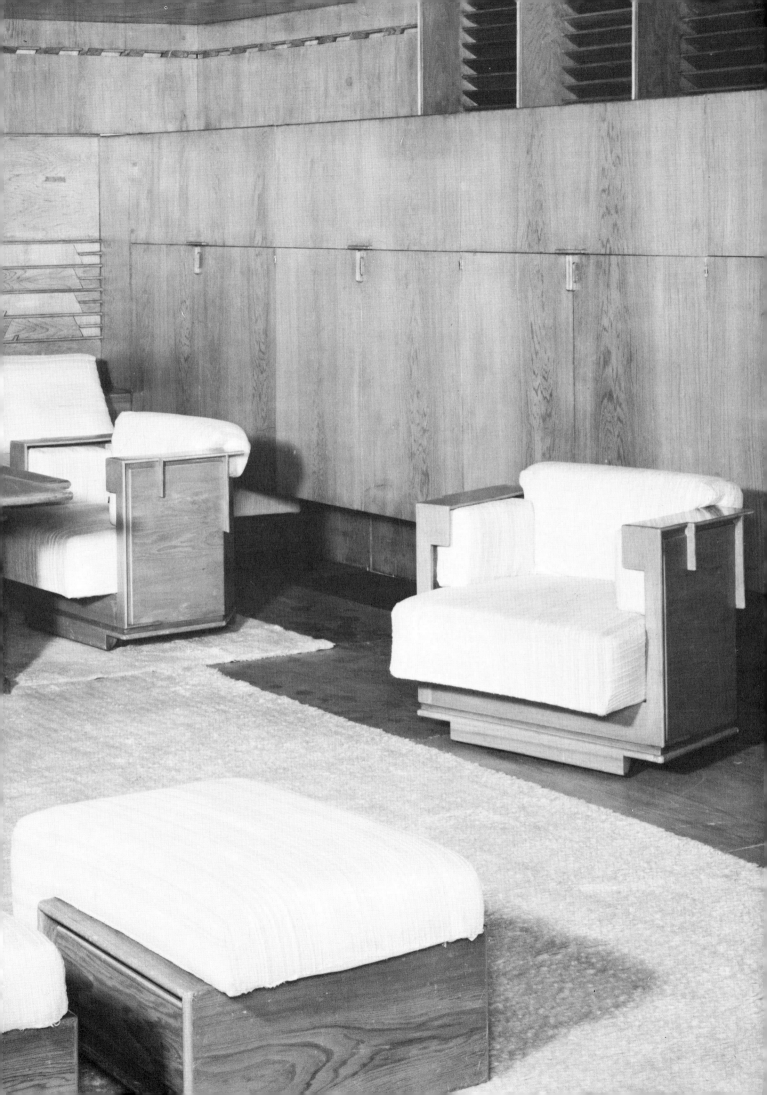

*(preceding spread) An interior by Frank Lloyd Wright,
reconstructed in the Victoria and Albert Museum, London*

(right) The State Capitol of Nebraska

of 55, and never saw his great work finished.

Although the Nebraska State Capitol does not seem to have been in any way directly inspired by the Paris 1925 Exhibition, in which the United States did not take part, the architecture, nevertheless, suggests a contemporary French influence more than that of the native American schools. The plan is square with four rectangular courts and a tower surmounted by a cupola rising from the centre, with a strong vertical emphasis in contrast to the surrounding prairies. The wall surface is in ashlar limestone, undecorated except for sculpture figures, which were integrated with the architecture and appeared to grow out of the stone. The form becomes more detailed as it rises to the head, and the exterior sculpture as well as much of the interior design is by Lee Lawrie.

The facades are strongly reminiscent of the French architecture of the time in that plain surfaces are contrasted with areas of carving rather than the surfaces being tied together with classical motifs and ornament. The cupola is crowned with 'The Sower', a figure by Lee Lawrie with pedestal standing 32 feet above the dome, cast in bronze, weighing 8½ tons and symbolising the agricultural beginning of civilisation. The symbolism throughout is that of Wisdom and Justice, representing the greatest figures in history, law givers rather than military heroes, and including Hammurabi, Akhnaton, Charlemagne, Solomon and Abraham Lincoln. The reliefs depict the presentation of Magna Carta and the signing of the Declaration of Independence.

There is much richness and colour in the interiors in mosaic, carving, leather work, tapestry and marble. The American Indians are acknowledged in places by representation and their tribal designs. Influences from many sources are evident in decorative motifs, from Assyria, Byzantium and Egypt, but they are all linked by the originality of the sculptor and the architect and succeed in achieving homology in design.

There are quite a few buildings in the United States in which Art Deco characteristics can be seen clearly. In New York, no. 570 Lexington Avenue of 1931 by Cross and Cross harks back in some respects to the Chicago Tribune and has quite a powerful originality of form and richness of effect. The Chrysler Building, also in New York, is spiky in effect and known as the 'swordfish'. Neither of these buildings derives directly from the Exhibition of 1925, but spring mainly from a native tradition that goes back to the work of Richardson, Daniel Burnham of Chicago and of course, Frank Lloyd Wright.

In Great Britain the 1925 Exhibition did not have much influence upon the architecture of the late 'twenties, neo-classicism still persisting in the great City banks designed by Lutyens, Sir Herbert Baker,

and Sir Edwin Cooper. The reconstruction of Olympia by Joseph Emberton shows more German or Dutch influence than French.

Art Deco made a brief appearance in London in 1929 when Lord Waring established his 'George the Fifth Period' furniture department in the famous Oxford Street establishment of Waring and Gillow. It was under the joint direction of Serge Chermayeff and Paul Follot, and many of the rooms had been designed by Follot and were similar in character to his work for Pomone at the Bon Marché in Paris. But the spirit was already changing and the designs that emerged from Chermayeff's studio were a reflection of this.

By now, I (M.T.) finally had left Paris and was living in England. I was very anxious to get some practical experience of industrial design and was very pleased to be offered a modest job in the furniture department and eventually in the studio. Meanwhile, my parents had decided to build a small house at Rye in Sussex and had chosen a site outside the old town, backed by a low cliff and facing Romney Marsh towards the sea.

After the Exposition, Frank Scarlett went to Dublin for three years to work under Professor R.M. Butler at University College and in his office, and, in 1928-29, he did some work in Italy and the United States before settling in London to private practice. I was his first client and wrote asking if he would design the house at Rye for my parents. Starlock was the result. We already possessed some Art Deco furniture acquired from Pomone. The rest of the fittings I eventually designed with the help of the draughtsmen in the Waring and Gillow studio. The major source of inspiration in the general conception of the design was the pavilion of L'Esprit Nouveau, especially the idea of making the living hall embrace two storeys.

The site presented some difficulties (continues M.T.) which the design overcame. Its simple, clean lines and balanced proportions stood out against the background of the wooded hillside and faced a sloping terraced garden. Below, there was a small pond with a fountain of stainless steel, now alas, vanished and, on the road level, a garage was located with a workroom or studio above. The internal plan, too, was both original in conception and entirely practical, a quality that was all too often absent in the houses of the period. Ian Nairn and Nikolaus Pevsner have this to say in the Sussex volume of the *Buildings of England* series: 'Frank Scarlett's Starlock, Rye, designed in 1929, is the first of the white and cubic buildings in Sussex and one of the first in England. Historians ought not to neglect it.' At the time, to Marjorie Townley, at any rate, it seemed appropriate and natural to think in such terms.

Sadly, Starlock had to be abandoned in 1940. The

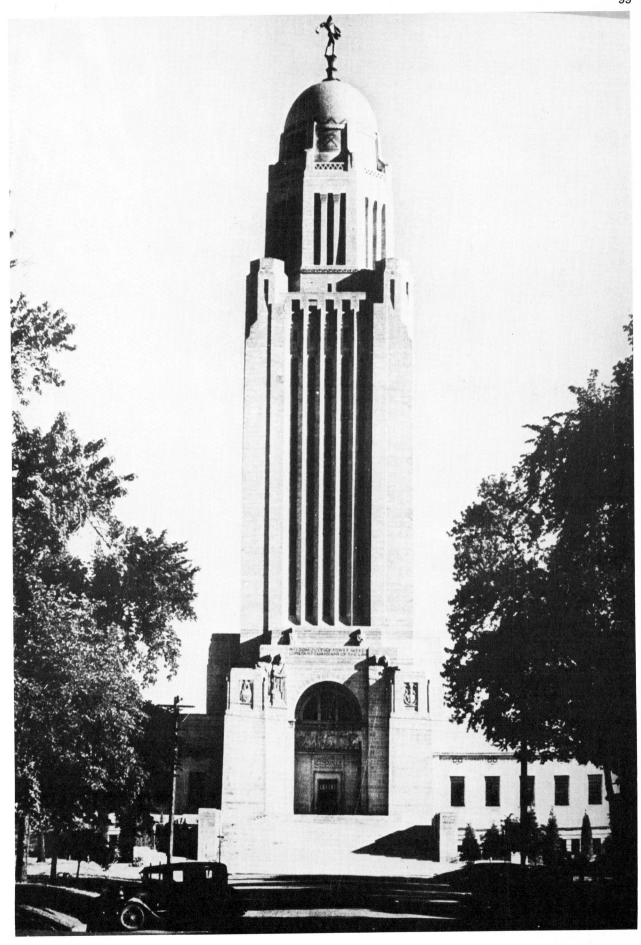

Battle of Britain was fought over the area, the house requisitioned and its freshness and beauty inevitably marred. It had influenced, however, the development of modern domestic architecture in England and was a wholly worthwhile venture.

There is no doubt that the spirit of the Expo, or what might be called with justification, a spirit of rebirth or renewal in the industrial arts had made an indelible impression. While it is certainly true, as has been said already, that economic and technological reasons as well as aesthetic ones favoured the simpler and more practical conceptions of the Swedish, Finnish and German designers, there were other factors that also should be borne in mind. People of discernment were horrified at the downright ugliness of the flood of production of objects in common use and, in most cases, at their impracticability. This applied equally to the often squalid adaptations of historical styles and to the so-called modernistic. Not unnaturally, perhaps, Mondrian's message of the relative significance of vertical and horizontal lines and the spaces created by van Doesburg's diagonals quite simply had not been understood. The result was an aggressively harsh and meaningless idiom.

In addition, a sociological factor existed. This was the no-man's land between the old way of life and the new. There was increasing dissatisfaction with domestic service as a profession, and the help available was mostly unwilling or untrained or both. Yet the houses remained as they had always been, designed to be run with at least a minimum of skilled labour. The average housewife faced a nightmarish task, but out of it came the demand for tools that were 'fit for their purpose', planned kitchens and simple furnishings.

The Design in Industries Association played a major part in educating the English public to appreciate and the manufacturers to supply goods that were basically well designed. Formed as early as 1915, by 1931 it was an influential body with around a thousand members representative of every aspect of industrial art. The president was Clough Williams Ellis, who was succeeded the following year by Frank Pick. Its principles were summed up in the statement that 'A product should primarily be fit for its purpose, and pleasantness in use should be obtained by the form and shape of the commodity rather than by the addition of ornament.' A message from the Prince of Wales began: 'If British trade is to hold its own in the markets of the world, it must do more than maintain the technical excellence in which it has so long enjoyed leadership; it must raise the standard of design in its products, for in design it is outstripped by other countries.'

And so the lessons of 1925 had been understood. People felt passionately about what became almost a crusade. Paul Nash, John Gloag, Wells Coates, Raymond McGrath and so many others were instrumental in effecting what was an almost revolutionary change

in outlook. It is significant that a great number of household utensils and fittings designed about this time are still to be found in the more avant-garde furniture shops. But all this is outside the scope of this book which is concerned with the imaginative colour and splendour of Art Deco and its endearing extravagance.

It is in the interior shopping arcade and public rooms of the Strand Palace Hotel and later the Cumberland that Art Deco made its earliest impact with the work of Oliver Bernard. He was, as has been said already, a master electrician who knew precisely how to achieve brilliance without glare, and who appreciated the use of moulded glass to diffuse light and the effect of reflection on metal and polished marble.

The Dorchester Hotel, by Curtis Green and his partner Lloyd, struck an entirely new note when it was built in 1930. Astylar and clad in faience, its mass commands the site as proudly as did Vuillamy's Dorchester House. The decoration is well controlled and confined mainly to string courses and iron railings leading to simply designed balconies, with no attempt to imitate the luxuriance of Brandt. The whole spirit of the building, nevertheless, brings it within the category of Art Deco, and it is all the more interesting that Curtis Green's previous work is mostly neo-classic. One possible criticism of the Dorchester is that the decorative motifs are a trifle thin for such a massive building.

In Finella, Cambridge, Mansfield Forbes, Master of Clare College and an enthusiastic patron of modern art, employed a young Australian architect, Raymond McGrath, just emerging from his student days, to transform the interior of his stucco Regency House in Queens Road. The result, distinguished by lavish use of mirrors and by subtle colours, led to a fresh outlook in interior decoration.

Of the work of the early 'thirties, the new headquarters of the Royal Institute of British Architects, the result of an open competition won by Grey Wornum, shows in its entrance hall and staircase a largeness of conception on a relatively constricted site that has some affinity with the Escalier d'Honneur of Charles Letrosne in the Grand Palais. French influence is also apparent in the beige marble engraved in low relief and in other details of the window linings of the hall used for receptions and exhibitions. Several of the designs that were submitted showed a similar trend, including the commended design illustrated here.

With the restrictions and austerity following World War II, little Art Deco survived. There is some to be seen in the interiors of the new office building attached to the Guildhall of the City of London in the early 'fifties by Sir Giles Gilbert Scott, architect of Liverpool Cathedral. Some notable Art Deco elements occur in the Livery Hall with plywood

panelling divided by pilasters that are rectangular and plain except for fluting, coved plaster ceilings concealing indirect lighting and other features in the Paris 1925 repertoire. The further extension to the offices and display areas built by his son a few years ago continues with a freer, almost baroque, modern style in Portland stone, granite and bush hammered concrete. Bracken House, by Sir Albert Richardson, P.R.A., champion of the neo-classic, must also be mentioned. Built in 1959 as the headquarters of *The Financial Times*, it is almost Art Deco with small bricks and red sandstone and Lalique inspired moulded glass panels, and it certainly has more character and colour than its neighbours. It is interestingly similar to some of the work of the brightest architects in Italy at that time.

In France as in England the direct influence of the Exhibition was not greatly in evidence. Probably the most striking is the Palais Chaillot in the Place du Trocadéro, laid out in the traditional grand manner of

Detail of a commended design in the competition for the new headquarters of the R.I.B.A.

Louis XIV, a central block with two quadrant wings embracing a garden with a pool flanked by monumental steps down to the Pont d'Iena on the axis of the Tour Eiffel. Deference to the ideas of 1925 is apparent in the simplicity of the stone wall surface and the style of the sculpture. Modern blocks of flats built in Paris, of which that by Mallet-Stevens is still the most distinguished, are controlled by building regulations to conform with existing height levels, facing material and frontage lines. Much as some older French ladies may deplore the street scene 'avec ces affreux gratte-ciels', in terms more applicable, one would think, to lower Manhattan, Paris does not seem, even today, to have changed that much in the last fifty years, not nearly so greatly as parts of London. True, there is the Montparnasse Tower, which is a pity, and that of the university and also the fast traffic along roadways once the upper quais, which, I believe, will be tunnelled eventually, the underpasses at the bridges being a great gain. Along the Côte d'Azur there is plenty of Art Deco architectural detail, particularly in balconies and gates, but this is not generally of a high

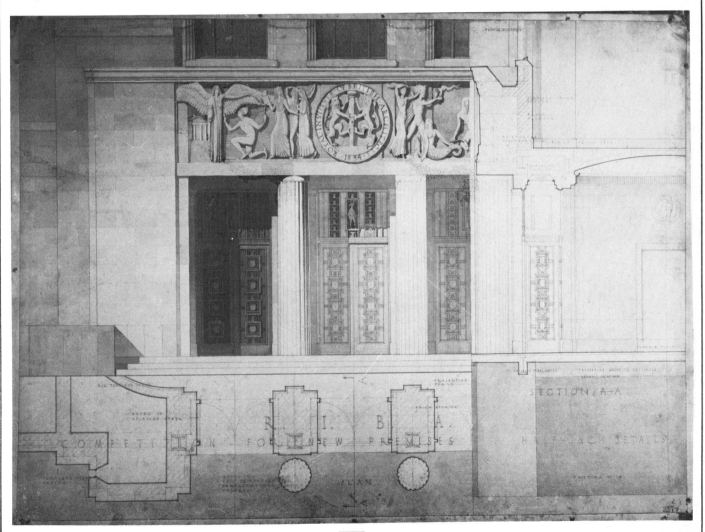

order and now looks very démodé. One impressive monument in the Midi is the War Memorial at Nice, hewn out of the rock face of the Basse Corniche.

In the Italy of the late 'twenties Art Deco was submerged in the Mussolini style of which the less said the better. One survival of Art Deco is seen in Gio Ponti's work both in architecture and decoration, his greatest achievement being the Pirelli skyscraper in Milan. In this building, erected in 1964, the architect has eschewed the rectangular slab almost universal in the Europe of the '50s and adopted instead an elongated eight sided plan form. The interior treatment is functional but has a richness of form and materials native to Italy.

In Russia and the other countries now behind the Iron Curtain the imaginative quality of the art of the early 'twenties was submerged in the monumentality decreed by Stalin. The Scandinavian countries never having embraced the French ideas of Art Deco, particularly in architecture and furniture, continued developing their own native traditions and maintained a high quality of detail in design and workmanship. The most expensive Danish porcelain and engraved

Watercolour of Starlock by Frank Scarlett

Swedish glassware, in forms very similar to those exhibited in Paris in 1925, can be bought in London today. Nor do Holland and Belgium seem to have developed very far in architecture and the industrial arts since the Exhibition.

In all countries since World War II, the emphasis has been on planning, economics, development and speculation while aesthetic considerations tended to become secondary, except in the minor visual arts where textiles, youthful fashions, pop music, mass produced furniture, drama and the film flourish. The art of the poster is almost non-existent. Even the architecture of the nineteen fifties and 'sixties, typified by prefabricated point housing blocks and 'wall span' offices, i.e. with metal, usually aluminium, frames covering the whole face of a building which is necessarily rectangular with plastic or coloured glass spandrel panels, now are out-dated and dirty looking. World Depression number two may be upon us. What comes next? What progress in the arts of design and decoration has been made between 1925 and 1975?

Making a comparison is difficult because of the momentous changes that have taken place. There has been a great social levelling and, in general, Europeans have better material standards of living, while the very

rich are fewer. There is greater freedom of thought and morals. Technology has expanded and, therefore, become more specialised, while transportation is quicker and perhaps more comfortable. I believe, however, that human beings have not changed so greatly as one might have expected and fundamentally still remain very much the same, having the same basic needs in their surroundings, where they live, work, where they go for recreation and how they fulfil their spiritual needs.

One of the most unfortunate results of the escalation of traffic and commercial development is that whole areas of our cities, towns, villages and countryside have been devastated by the demands of 'progress' and many individual buildings of great value have been demolished. Now that the Adelphi and the Euston Arch have gone and the Regent's Park saved only by a hair's breadth, there has been, under the powers of the Planning Acts, considerable expansion of the listing of buildings of architectural and historic interest and demarcation of conservation areas. This is a very good thing, but there is a danger at the moment that it may go too far and seek to include too many buildings of little intrinsic value that are obsolete, decayed and cannot be made to

serve a useful purpose. In this case, a reaction is likely to take place that will again put our best remaining buildings in jeopardy.

From personal experience as an architect, having built a few blocks of what used to be called 'working class' flats, for which term there is no sufficiently precise alternative, I (F.S.) would say that there has been a very great improvement in the appearance of the interiors of such State-aided housing. Whereas before 1950 they were pathetically bleak, the majority are now pretty, well kept and show that the tenants love and are proud of their homes. This is not, I believe, only due to the fact that people have more money but also to the proliferation of women's magazines and the trend to 'do it yourself' in decoration. As a result, designs for wall paper and cheap mass-produced furniture have improved greatly.

At the other end of the scale, the wealthy, in general, still prefer old houses, antique furniture and old masters, including Impressionist, with cut glass

Interior of Starlock, decoration and ensemble by Marjorie Townley

and traditional china and silverware. Any estate agent will testify that neo-Georgian houses sell best. Unfortunately, most of these have standard architectural 'features' in wood or fibre glass to designs that would have made Thomas Paine turn in his grave. If they must have copy books, why cannot the manufacturers look at the old ones? Even Lutyens did not scorn to carry Batty Langley's *Builder's Jewel* in his pocket.

The indecision about the future of Piccadilly Circus is a symptom of the lack of conviction of our time. Twenty years of discussion, public and private, negotiations and schemes have resulted in a design that is at least negative but one wonders if a better coherence would have been achieved in carrying on with Blomfield's elevations, which are listed, of Swan and Edgar's and Lillywhite's, perhaps with some of the more baroque features omitted. What is disheartening is the lack of any positive standards on the part of architects as well as the public. It is the former who should lead.

There are a few inspiring modern buildings in the country, for example, Coventry Cathedral, the Barbican, the Commercial Union office in St. Mary Axe, the new Institute of Chartered Accountants by William Whitfield which carries on the original by John Belcher. The National Theatre gives promise of being another, but these are isolated examples compared with the vast quantity of mediocre and soulless new buildings.

It is in industrial design that the greatest progress is seen. Refrigerators, sewing machines, all kinds of kitchen equipment and office furniture, even the smallest, most everyday articles are far better designed in Britain and France than they were even

15 years ago; cars also, but here the lead is taken by France and Italy. The firm of Olivetti have had enormous influence not only in Italy but all over the world, not alone in the standard of design in their typewriters but also in their buildings, advertising and throughout their products. In Britain the Council of Industrial Design, the Royal Society of Arts and the work of Sir Paul Reilly at the Design Centre have combined to raise the standard of design. It is odd and sad that architecture, rightfully the mistress of the arts, should lag behind.

From the height of the emotional Art Nouveau in 1900, the arts turned to the pictorial or picturesque in 1925. Then this was succeeded by the intellectualism of De Stijl and the Bauhaus which remained the spearhead of progressive thinking in architecture and the industrial arts until Fascism and World War II, followed by austerity successively made a pragmatic application of their philosophy compulsory. As conditions improved in the 'fifties, this approach was readily accepted not only by local authorities with extensive housing programmes to fulfil but also by speculative developers and manufacturers whose only criterion was maximum profit.

Now we are ready for a return to humanity and romanticism; but with world wide inflation and political problems, it is doubtful whether we in 1975 shall be able to afford anything more than fulfilling basic needs at least for a few years. Perhaps the best thing is the remembrance of things past.

This is our contribution.

Marjorie Townley
Frank Scarlett
1 January 1975